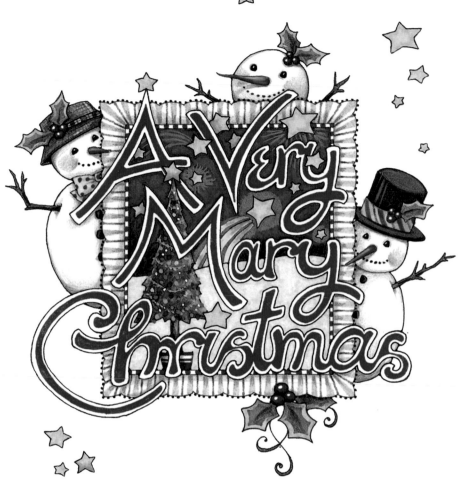

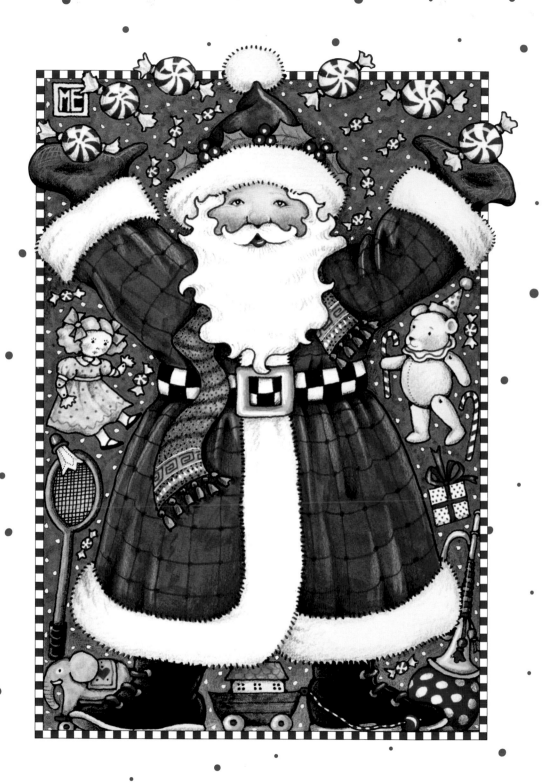

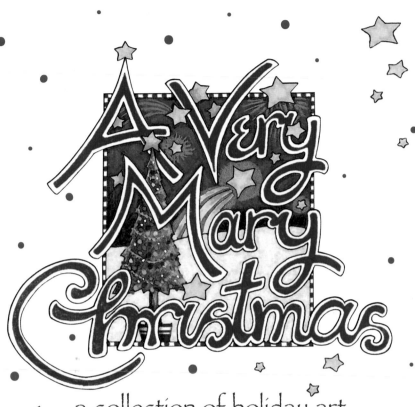

A Very Mary Christmas

a collection of holiday art

Illustrated by Mary Engelbreit

**Andrews McMeel
Publishing**

Kansas City

www.andrewsmcmeel.com
www.maryengelbreit.com

 is a registered trademark of Mary Engelbreit Enterprises, Inc.

99 00 01 02 03 Mon 10 9 8 7 6 5 4 3 2 1

Library of Congress Cataloging-in-Publication Data

Engelbreit, Mary.
 A very Mary Christmas : a collection of holiday art /
illustrated by Mary Engelbreit.
 p. cm.
 ISBN 0-7407-0203-3 hardcover
 1. Engelbreit, Mary Catalogs. 2. Christmas in art Catalogs.
 I. Title.
 NC975.5.E54 A4 1999
 741.6'092--dc21

 99-33366
 CIP

Illustrations by Mary Engelbreit
Design by Stephanie R. Farley

ATTENTION: SCHOOLS AND BUSINESSES
Andrews McMeel books are available at quantity discounts with bulk purchase for education,
business, or sales promotional use. For information, please write to: Special Sales Department,
Andrews McMeel Publishing, 4520 Main Street, Kansas City, Missouri 64111

contents

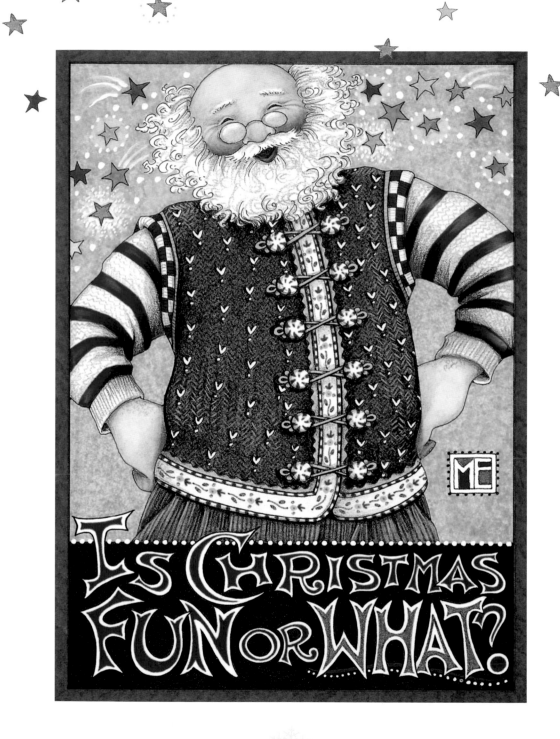

IS CHRISTMAS FUN OR WHAT?

introduction

i love Christmas! I love everything about the Christmas season. (And for me, it is *definitely* a season–one day a year would never be enough!)

I love the language of Christmas—those peculiar words you only hear during the holiday season . . . wassail, sugarplums, tinsel and garland, swaddling clothing, eggnog . . . even Little Cindy Lou Who . . .

I love Christmas because it's a feast for the senses. . . the first glimpse of "old friend" ornaments as they're unearthed from the box in the back of the closet, and the pine forest smell of the freshly cut tree that these cherished decorations will soon transform . . . the comforting sound of a favorite holiday hymn being sung by an enthusiastic, if not pitch-perfect, group of carolers. All of these things trigger deep-rooted memories that transport me back to the Christmases of my childhood.

Oh, to be a child again at Christmas! After weeks of anticipation, list-making, school pageants, and attempted perfect behavior . . . when, at last, Christmas Eve would arrive, I'd lie wide awake in bed convinced beyond a doubt that, yes, I believe that *was* the sound of reindeer hoofs on the roof. And, yes, I believe those *are* sleighbells I hear ringing.

I love Christmas because it never fails to deliver those long-ago memories. And I love Christmas most of all because it reminds me again to *believe*.

I hope this book helps you conjure up your own treasured memories of this most magical season.

To you and yours, I wish you a Very Mary Christmas! ∎

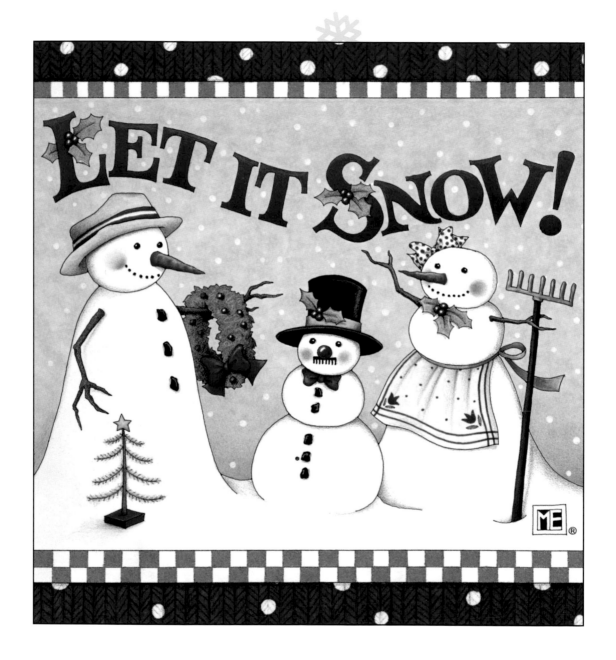

let it snow! 1

the tree is perfect. Family has gathered. Carefully wrapped gifts sit awaiting eager hands. The smell of an old-fashioned Christmas dinner drifts in from the kitchen. Only one thing could make this scene more perfect. There—in the sky—could it be? Reindeer? Santa?

No, silly. (It's only four P.M.!) It's snow! The *only* thing that can make a great Christmas better! Snow, snow, snow!

Snow on Christmas is nothing short of magic. Every flake a tiny, perfect miracle doing its part to transform the lucky little piece of the world where it falls. With each falling flake, the hard edges of the world get a little softer, a little safer.

And snow takes the edge off people, too. That's the amazing thing about snow—it makes us forget . . . but also, remember . . . remember a chilly afternoon spent outside crafting a pudgy pal to stand watch over the front yard . . .

remember falling blissfully backward into cushiony fluff and flapping our arms and legs to make a snow angel. Remember zipping down the biggest hill in the neighborhood piled three-deep on a toboggan. Snow ice cream, snowballs, snow forts, snowmen, snow days off school. . . .Why would anyone want to shovel this stuff aside? Snow makes amazing things happen, and snow at Christmas is the most magical snow of all.

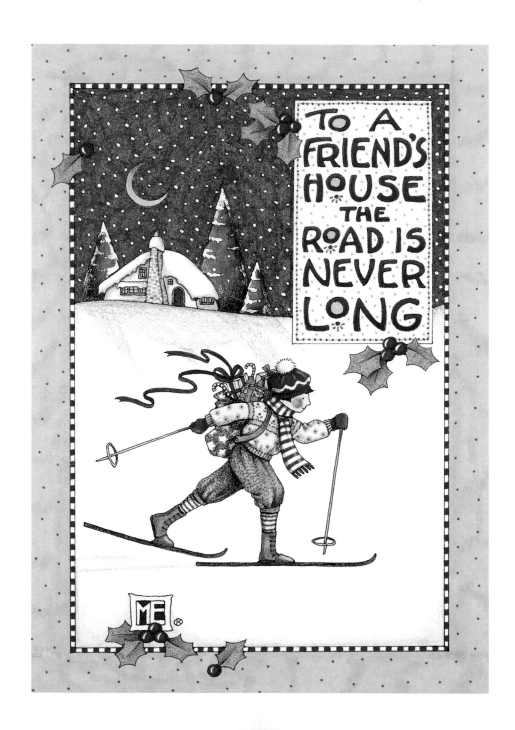

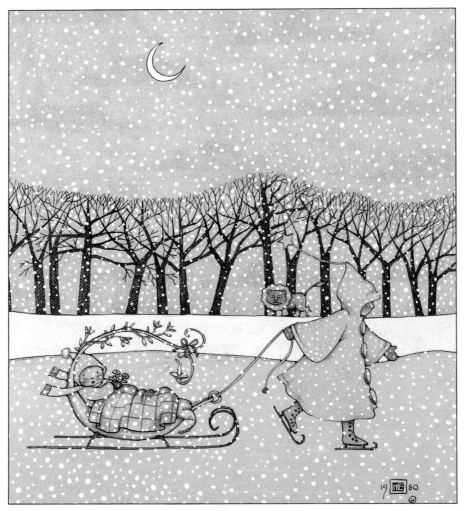

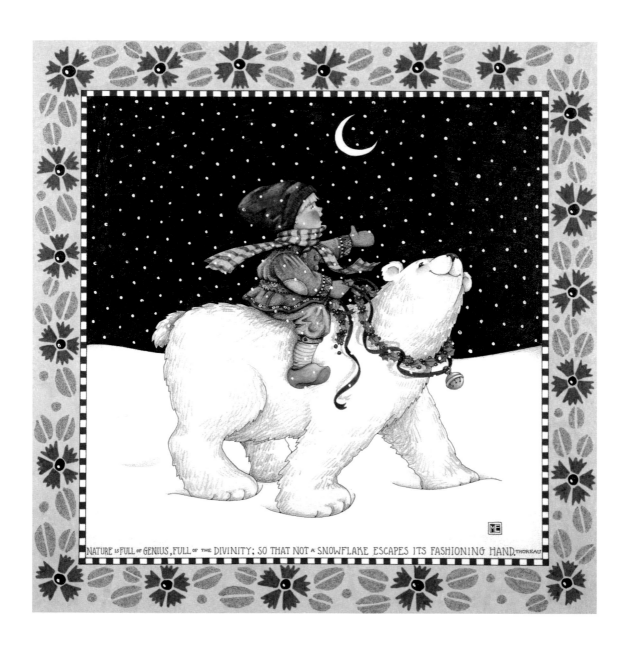

NATURE IS FULL OF GENIUS, FULL OF THE DIVINITY; SO THAT NOT A SNOWFLAKE ESCAPES ITS FASHIONING HAND. THOREAU

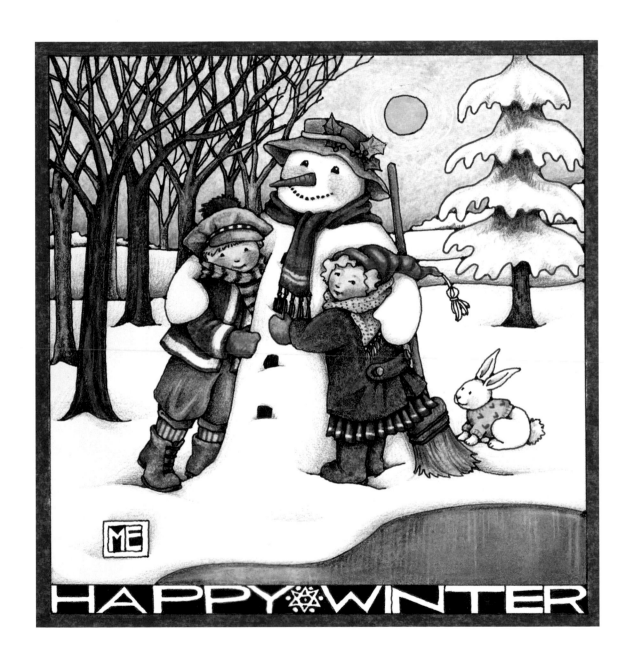

HAPPY✷WINTER

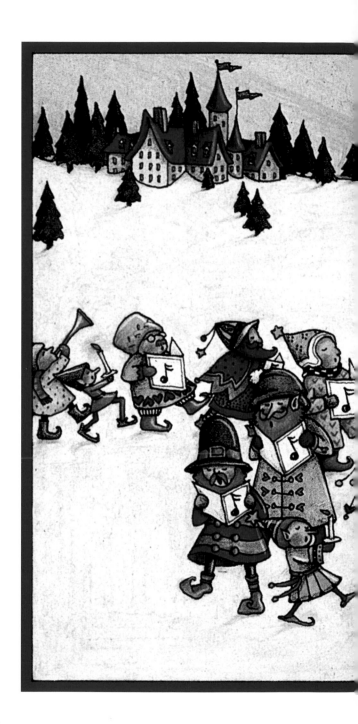

14

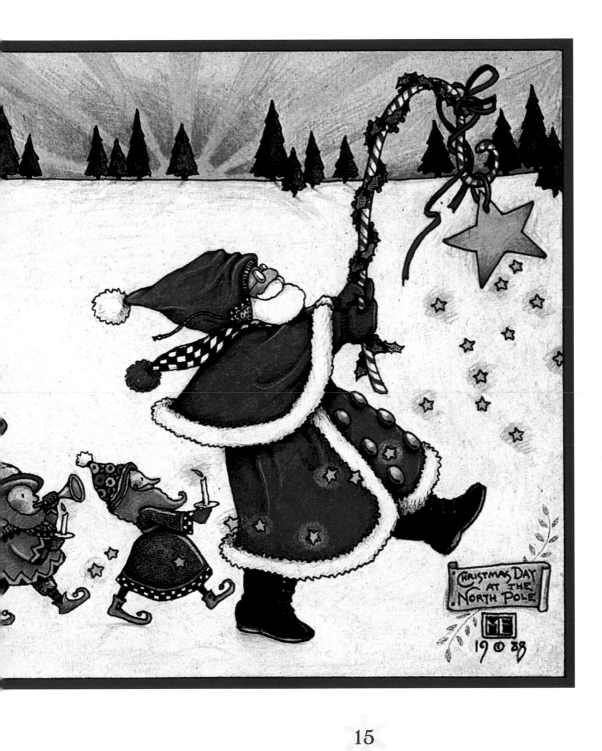

CHRISTMAS DAY AT THE NORTH POLE

19 © 88

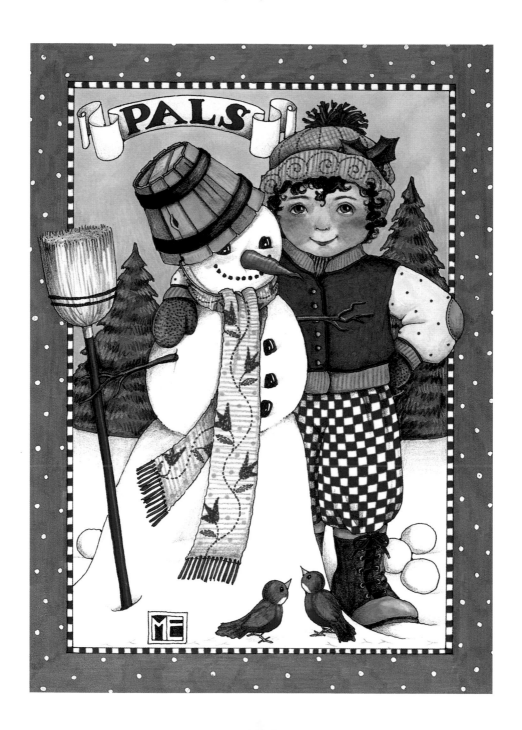

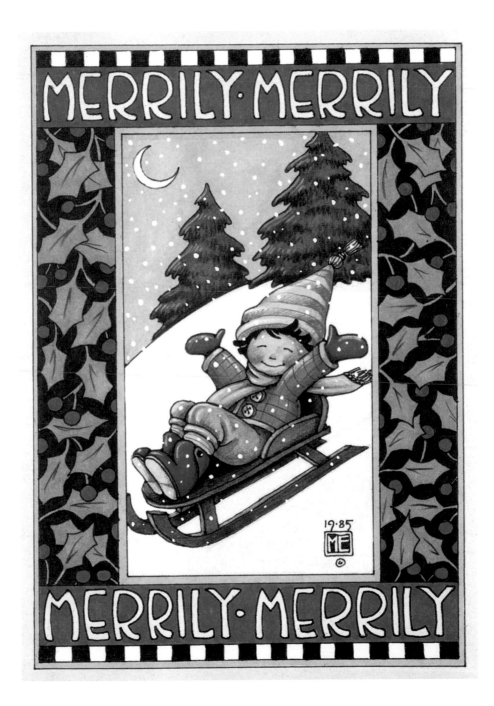

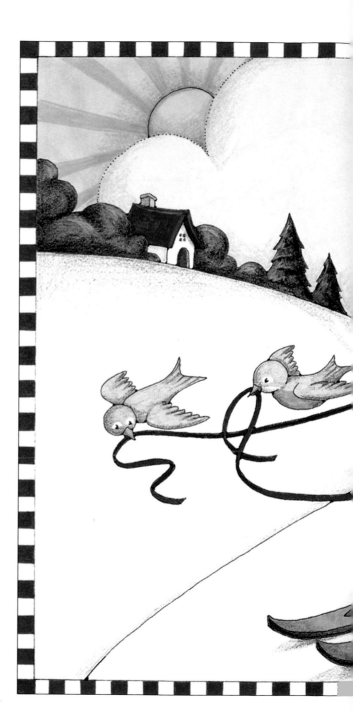

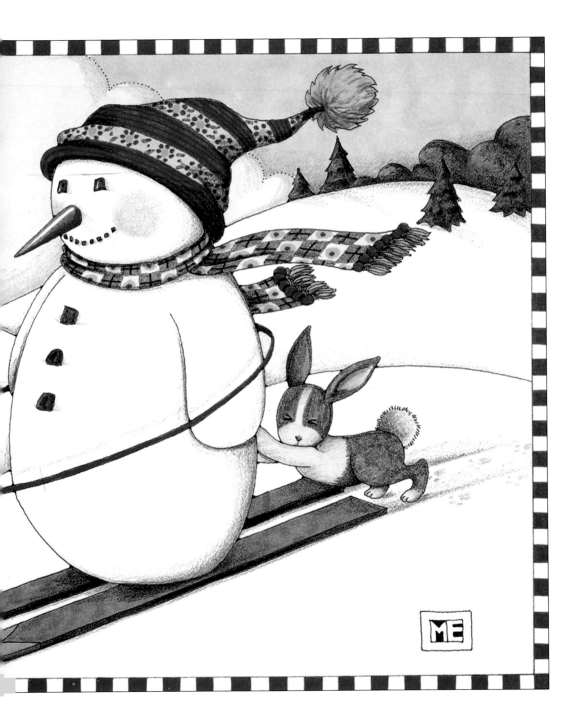

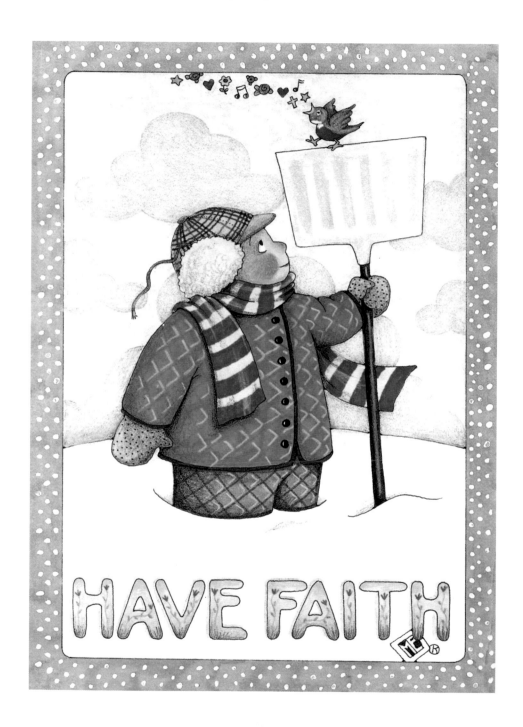

let it snow!

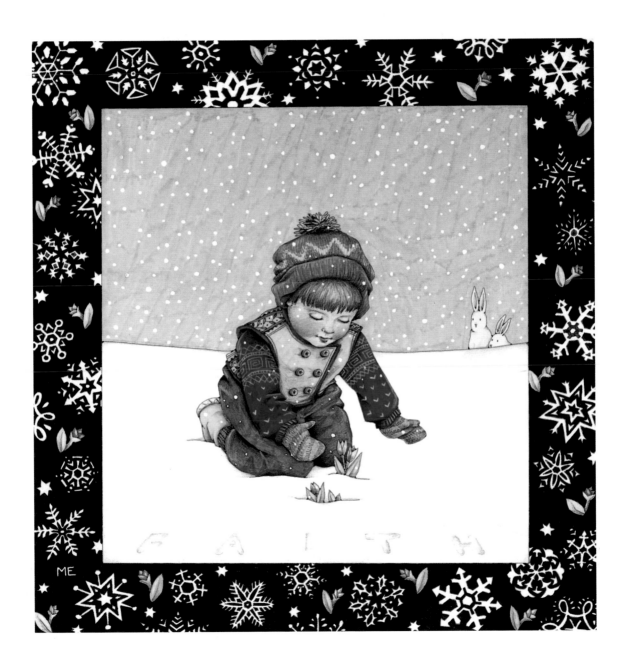

21

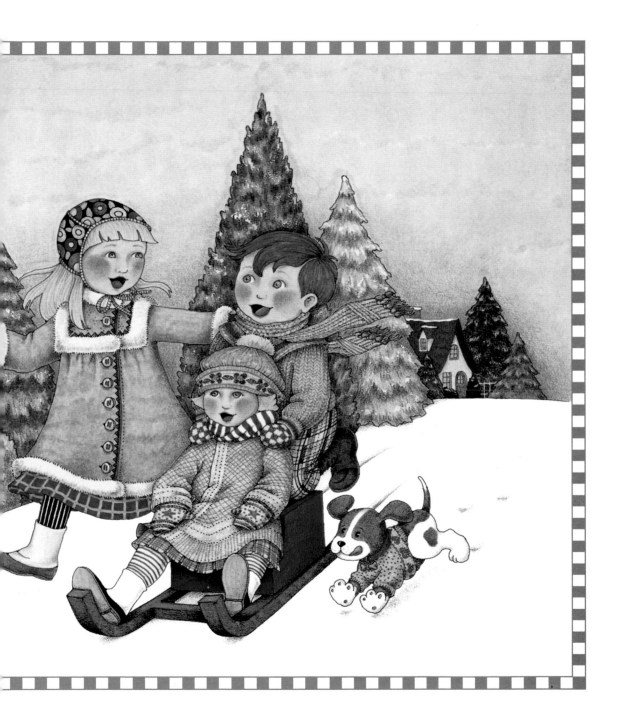

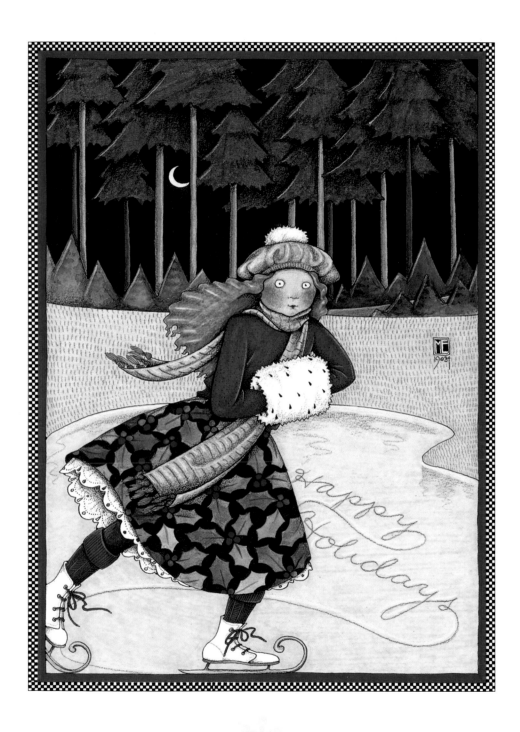

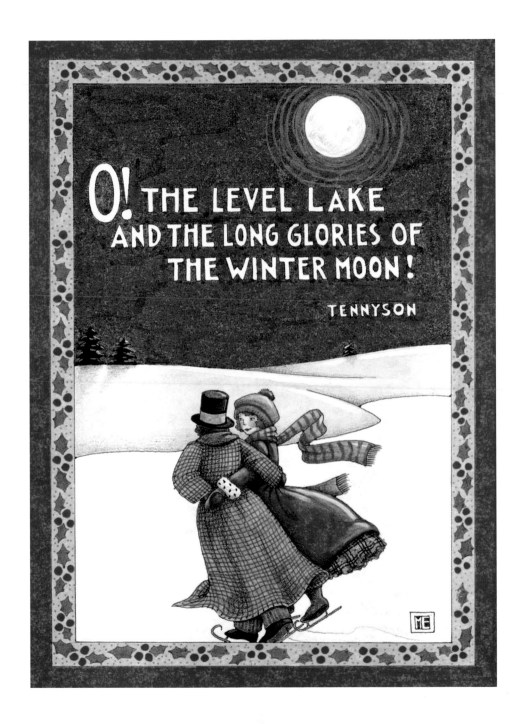

O! THE LEVEL LAKE
AND THE LONG GLORIES OF
THE WINTER MOON!

TENNYSON

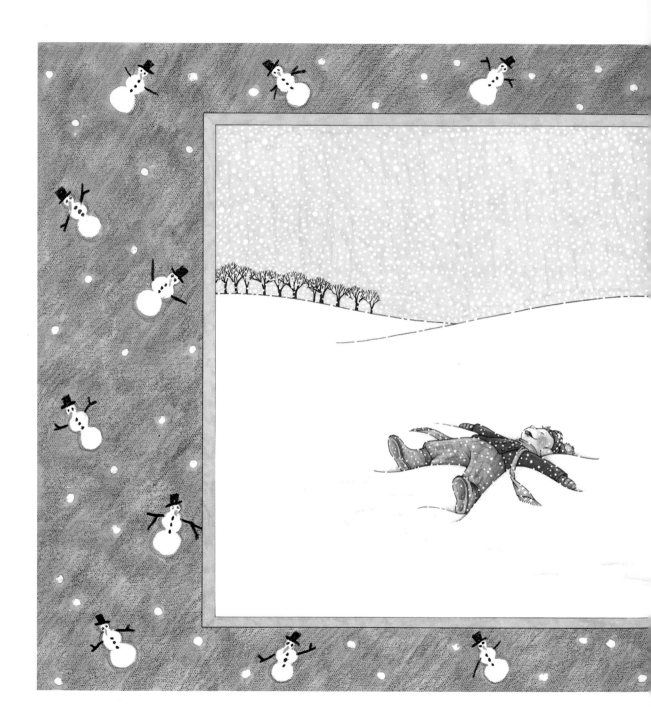

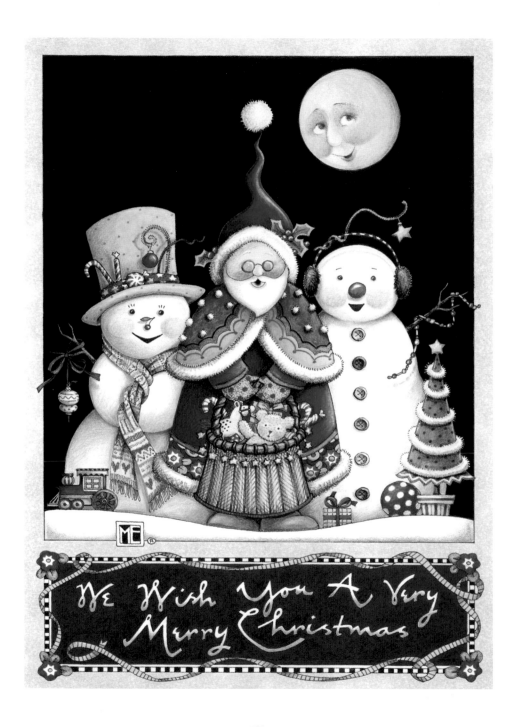

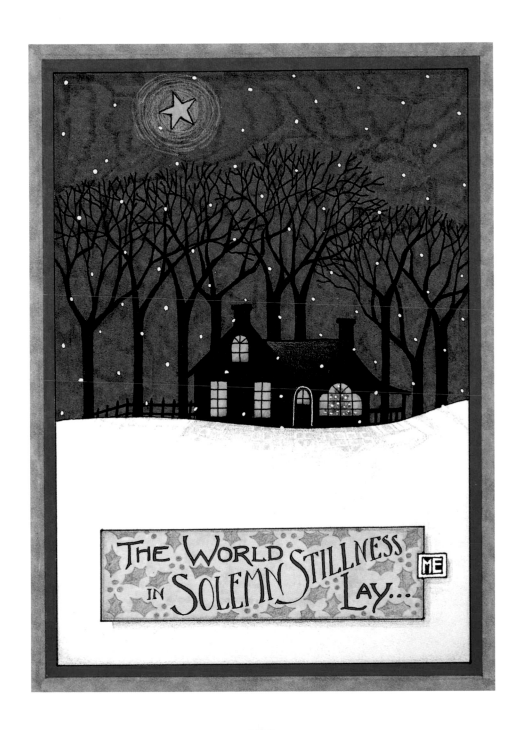

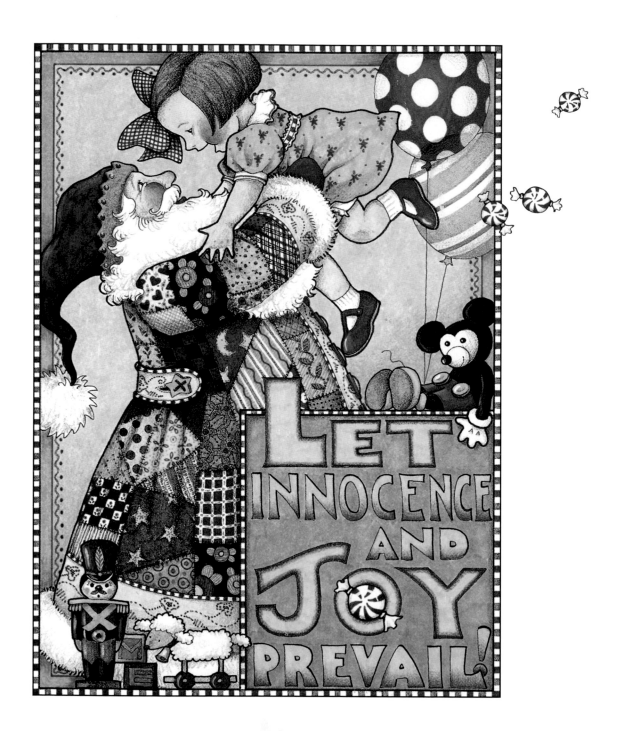

LET INNOCENCE AND JOY PREVAIL!

let innocence and joy prevail

Christmas with children is Christmas reclaimed. Truth be told, Christmas isn't quite complete in those years between childhood and parenthood. But add kids to the picture . . . ah, now that's Christmas!

What a privilege and a treat it is to introduce Christmas to a child. (After all, there should be *some* advantages to being a grown-up!) And what gift could be greater than the very *idea* of Christmas?

To pass along family traditions ("You may choose one present to open on Christmas Eve.") . . . to see the indescribable wonder in the eyes of a three-year-old on Santa's lap . . . to watch in rapt attention while your first-grade angel delivers his one big line at the school pageant ("Hark! Harold the Angel sings!") . . . to tell in a hushed tone the story of the very first Christmas . . . these are magic moments all.

Christmas is for all of us, it's true. But being able to see Christmas through the eyes of a child is the greatest blessing of all . . . and that is the gift that children give to us.

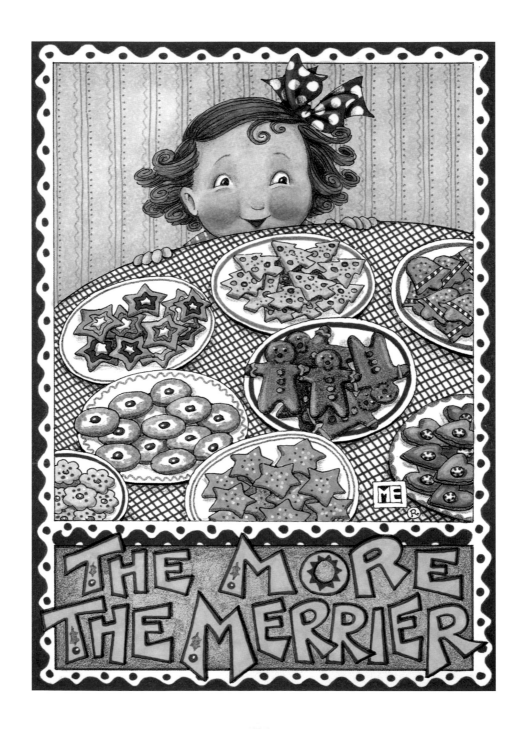

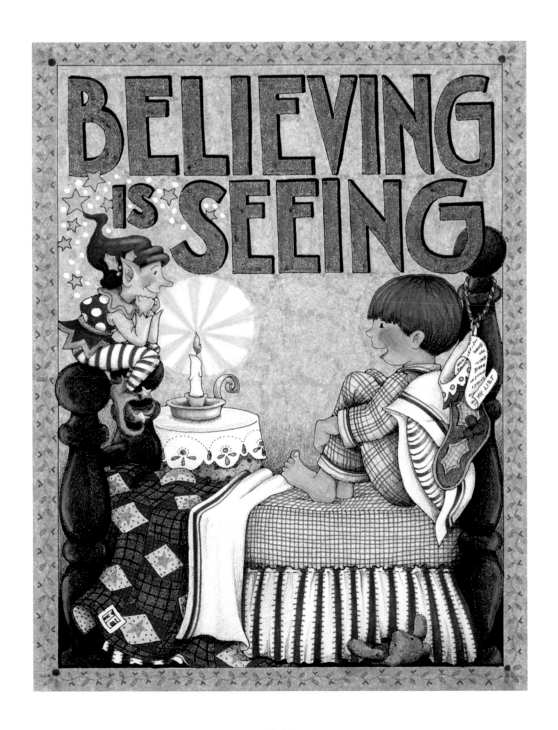

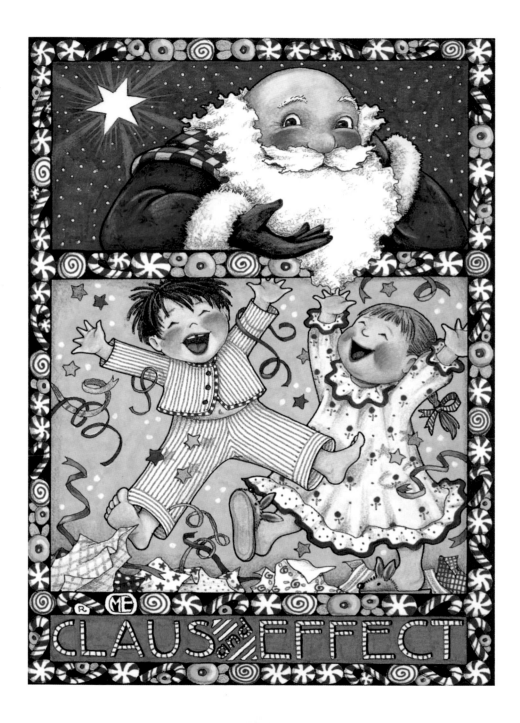

CLAUS and EFFECT

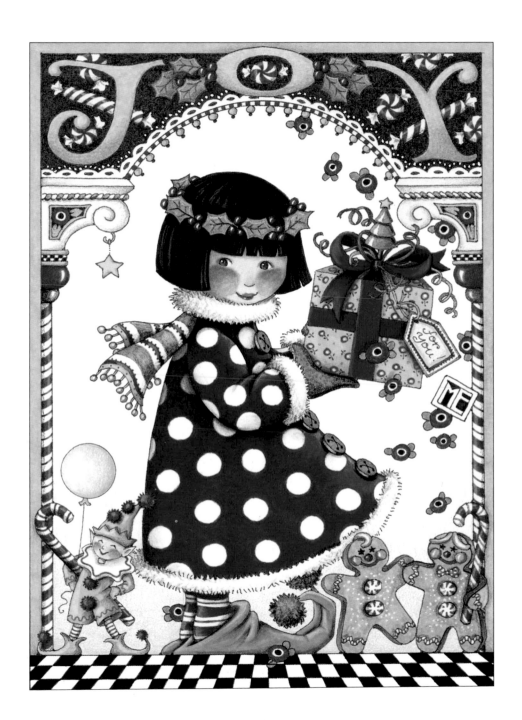

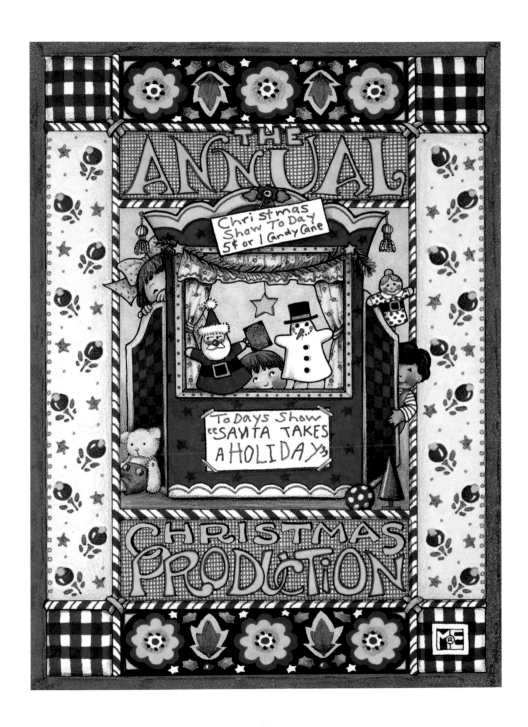

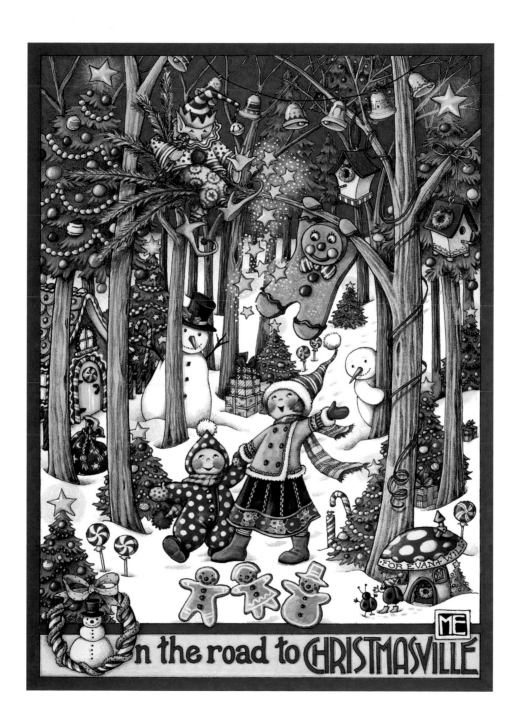

on the road to CHRISTMASVILLE

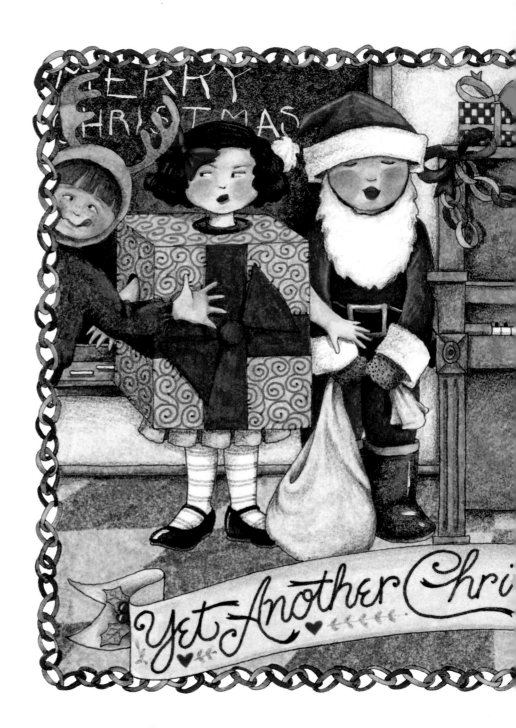

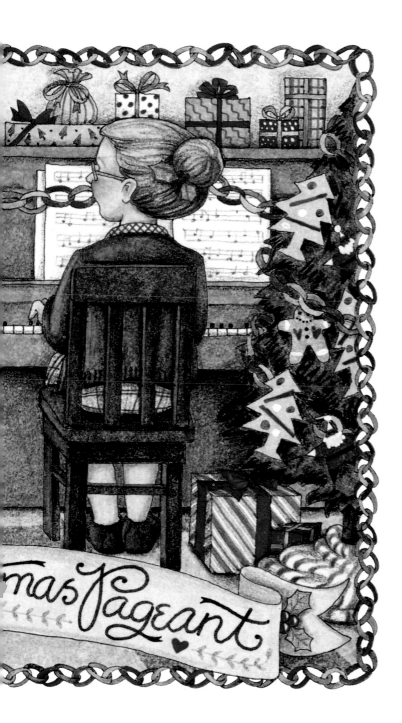

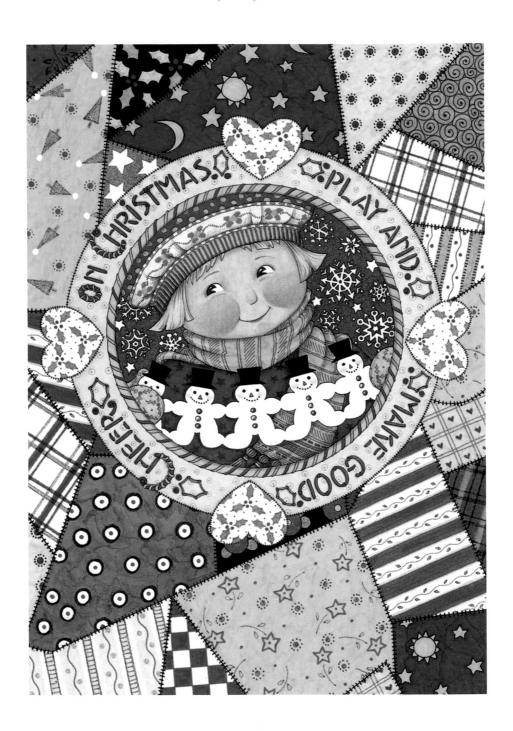

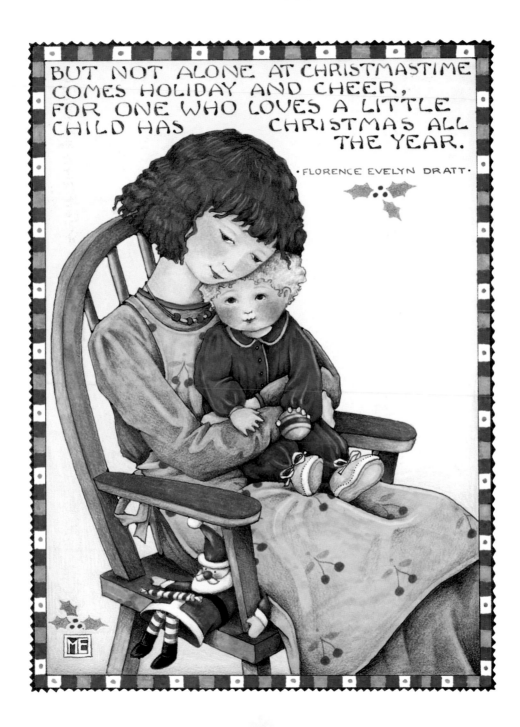

BUT NOT ALONE AT CHRISTMASTIME
COMES HOLIDAY AND CHEER,
FOR ONE WHO LOVES A LITTLE
CHILD HAS CHRISTMAS ALL
 THE YEAR.

·FLORENCE EVELYN DRATT·

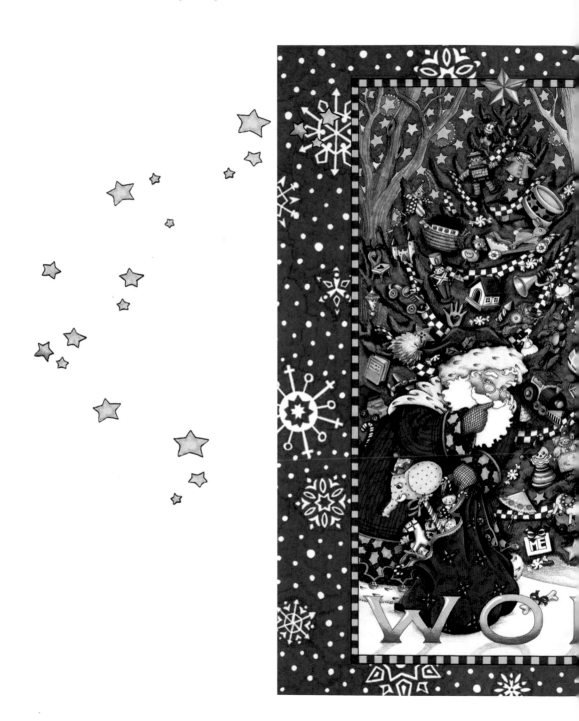

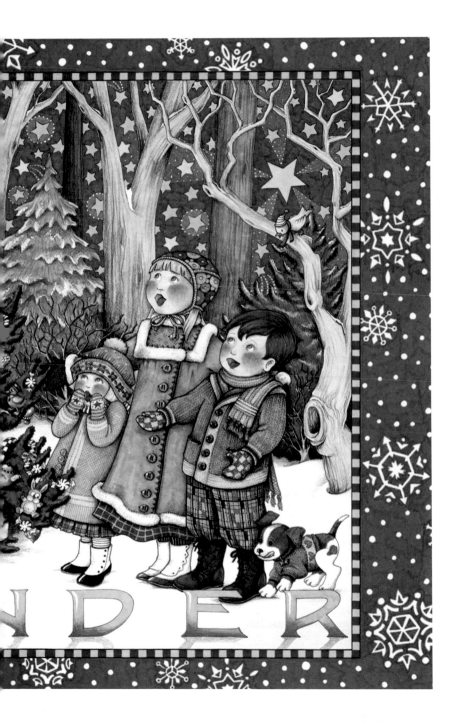

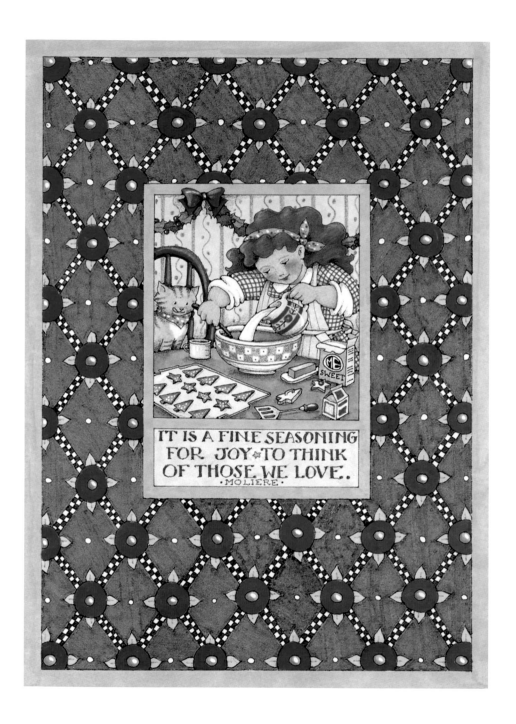

IT IS A FINE SEASONING FOR JOY ✦ TO THINK OF THOSE WE LOVE. ·MOLIERE·

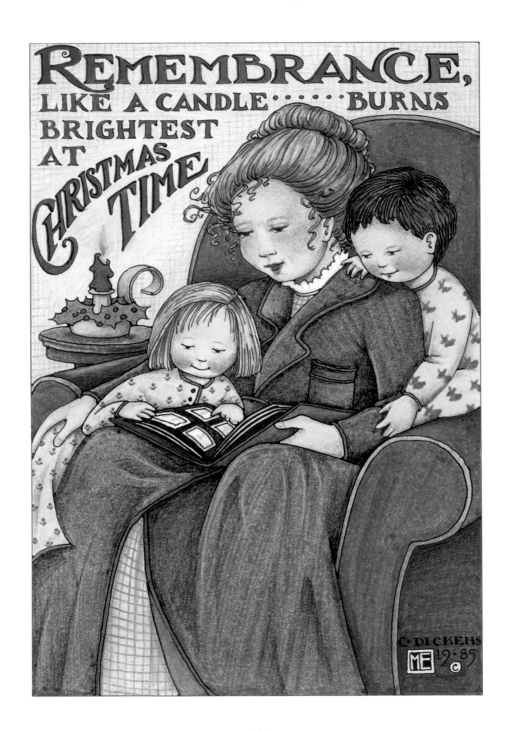

REMEMBRANCE, LIKE A CANDLE·····BURNS BRIGHTEST AT CHRISTMAS TIME

C·DICKENS

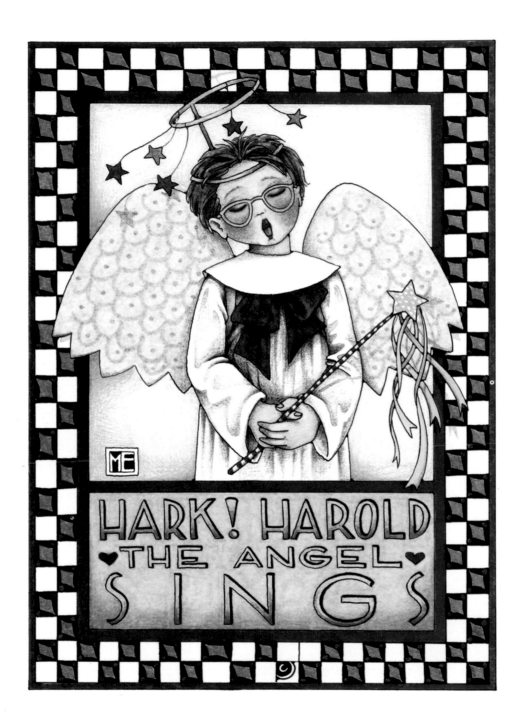

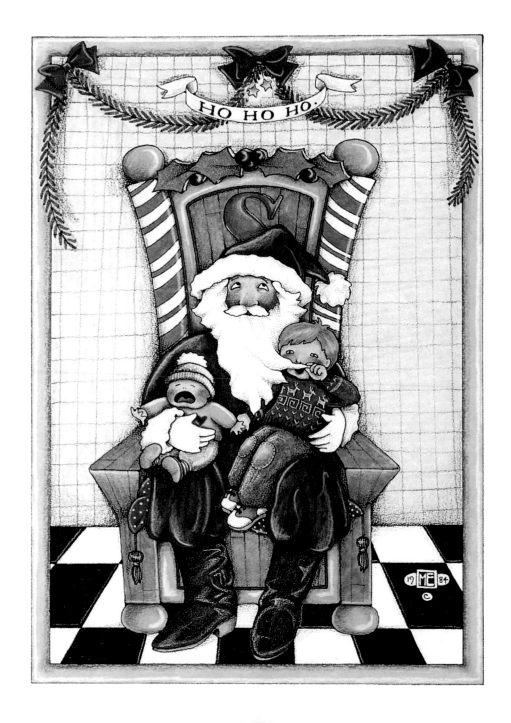

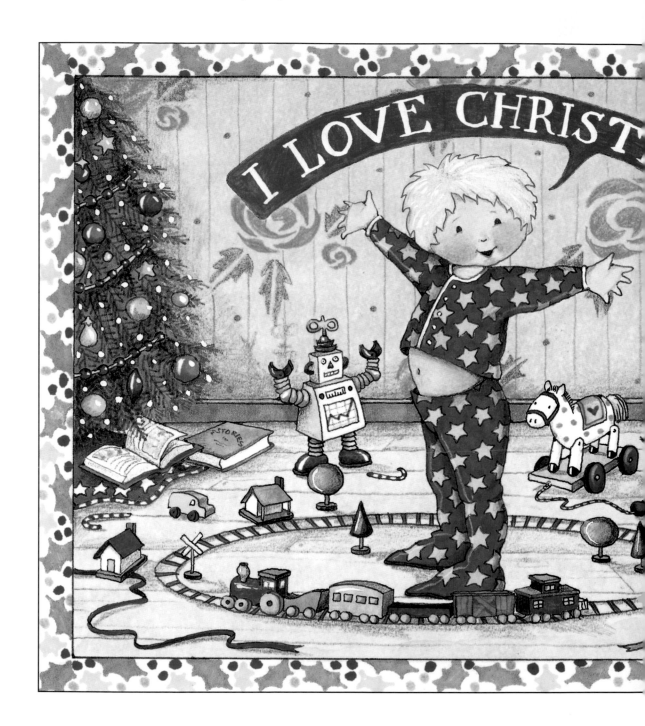

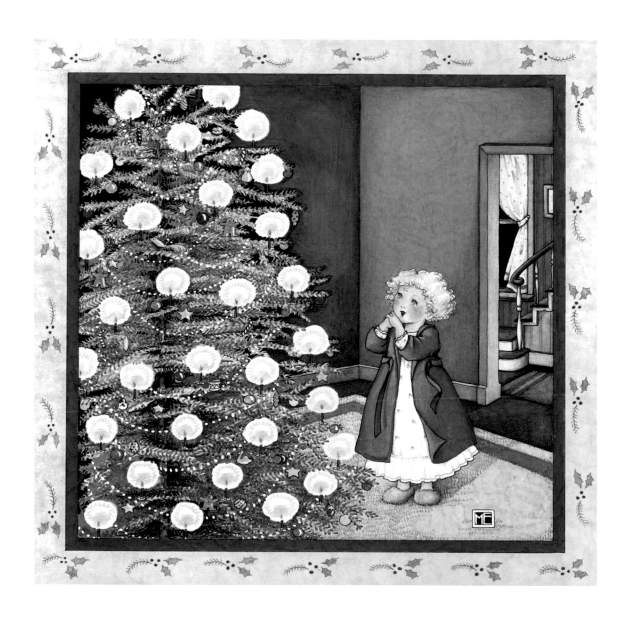

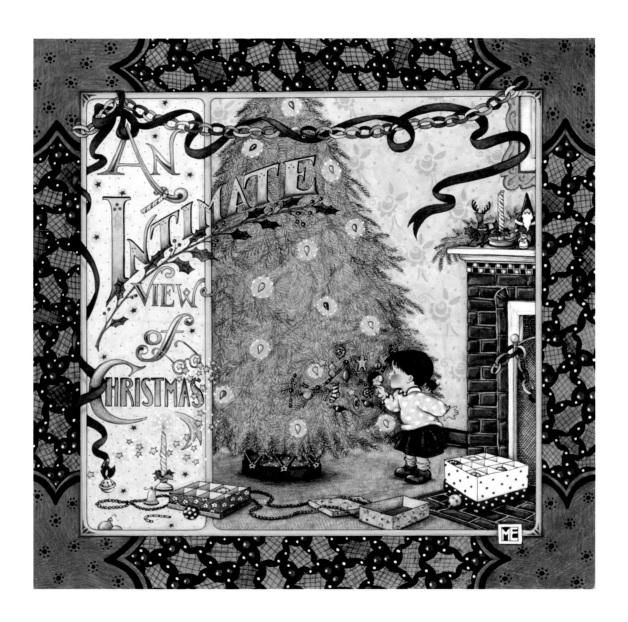

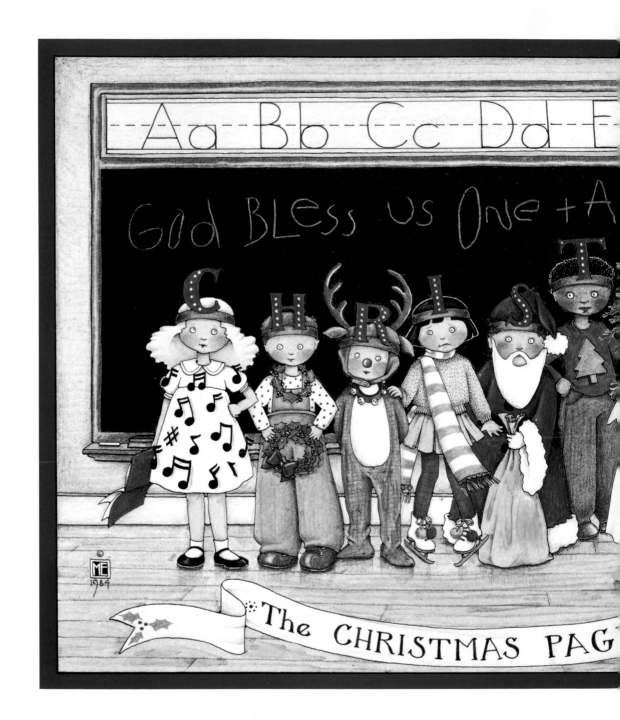

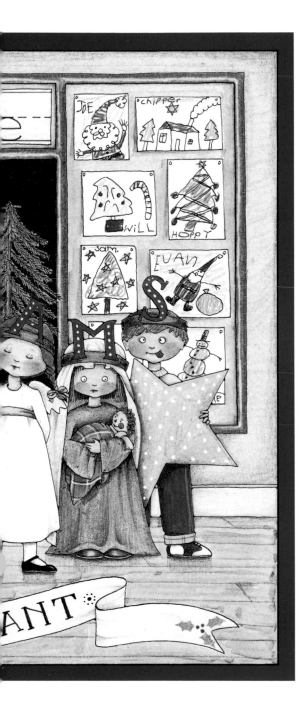

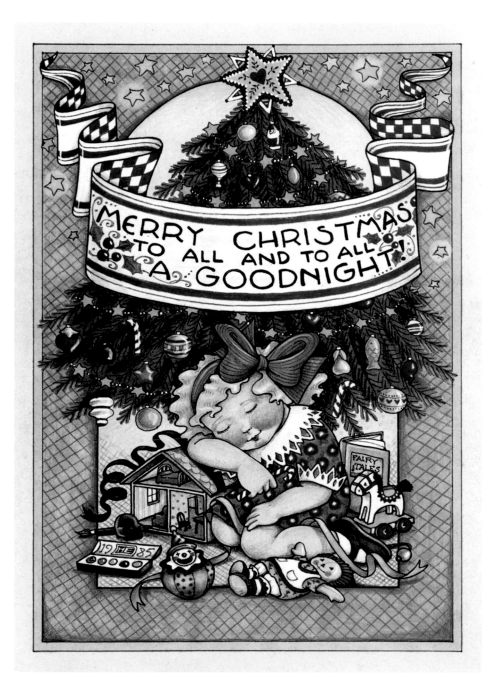

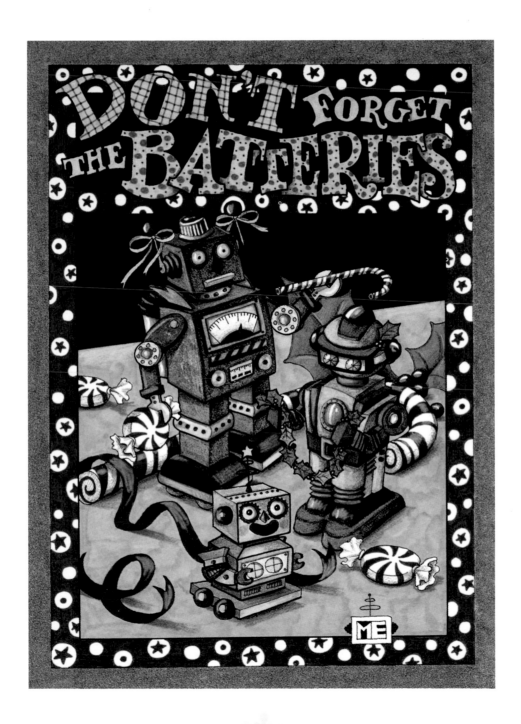

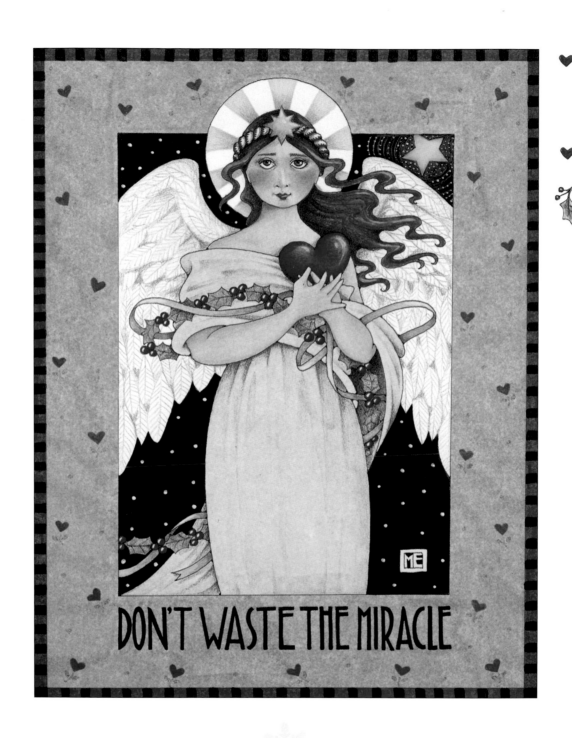

DON'T WASTE THE MIRACLE

don't waste the miracle

In all the holiday hustle and bustle, it's often too easy to forget . . . the real reason we celebrate this season . . . "Out of the darkness, we have light."

Long ago, a miracle of selfless love illuminated our world, and each year the miracle is born anew at Christmas. In houses of worship all over the world, communities come together and voices join as one to herald the arrival of God's only son. "Angels we have heard on high . . ." On this day, we are one people.

Christmas is a miracle, and Christmas is a gift—a time to renew lapsed relationships, revel in the love of family, strengthen our spirit, and open ourselves up to profound joy . . . for a savior reigns, and peace on earth and goodwill toward men are truly within our grasp.

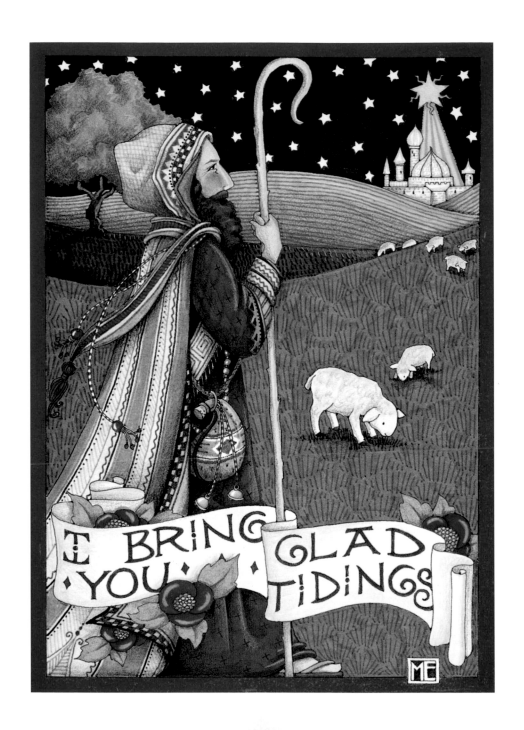

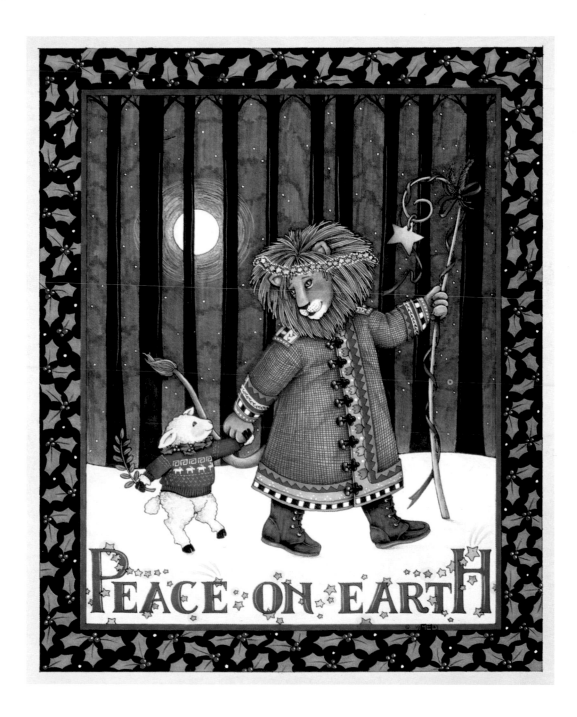

PEACE ON EARTH

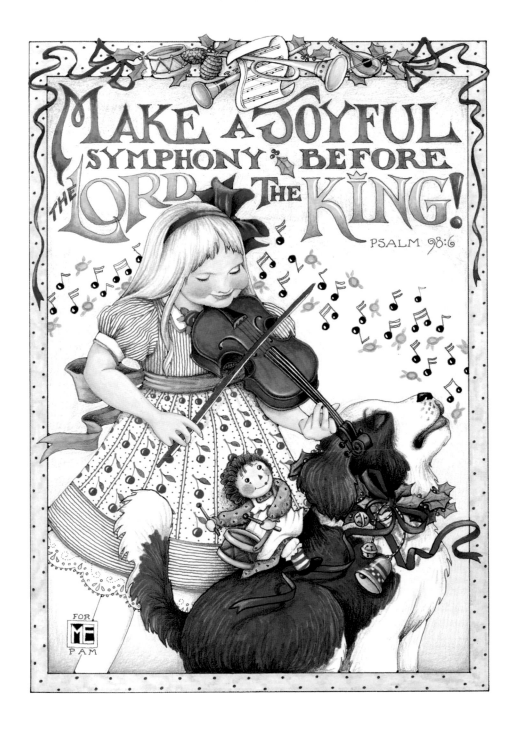

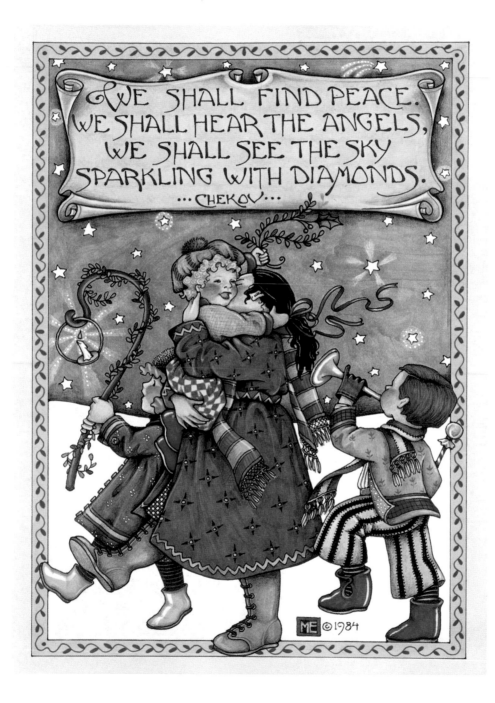

WE SHALL FIND PEACE.
WE SHALL HEAR THE ANGELS,
WE SHALL SEE THE SKY
SPARKLING WITH DIAMONDS.
···CHEKOV···

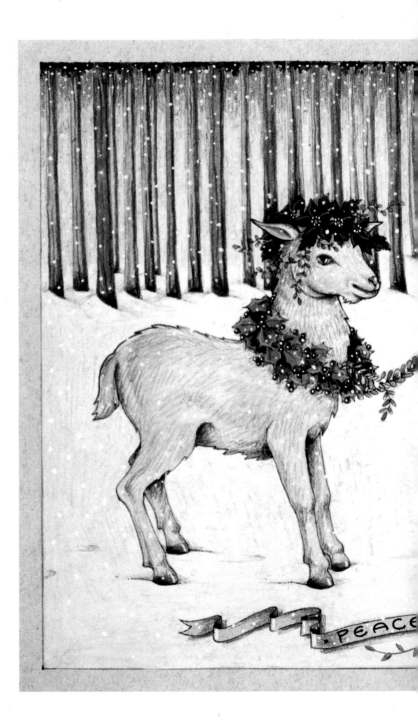

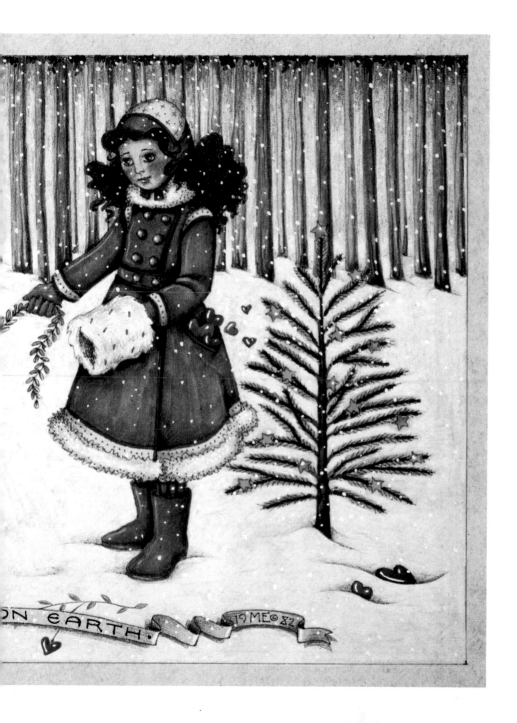

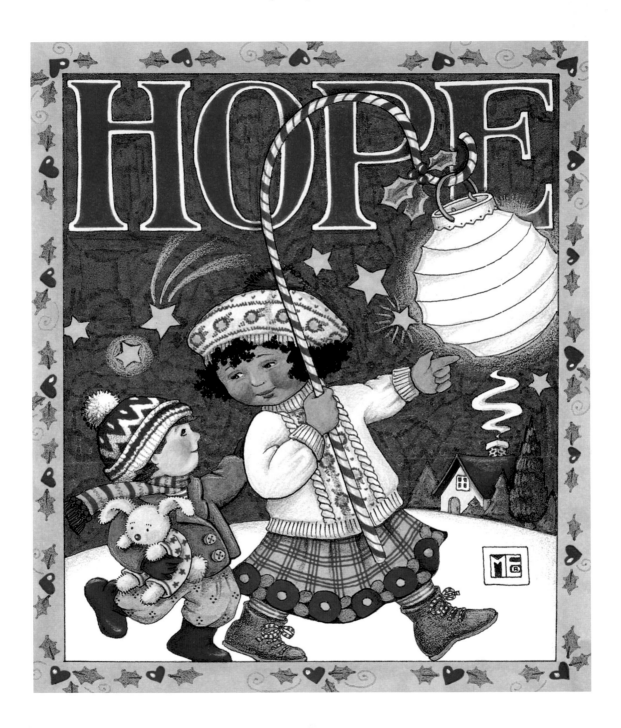

HOPE

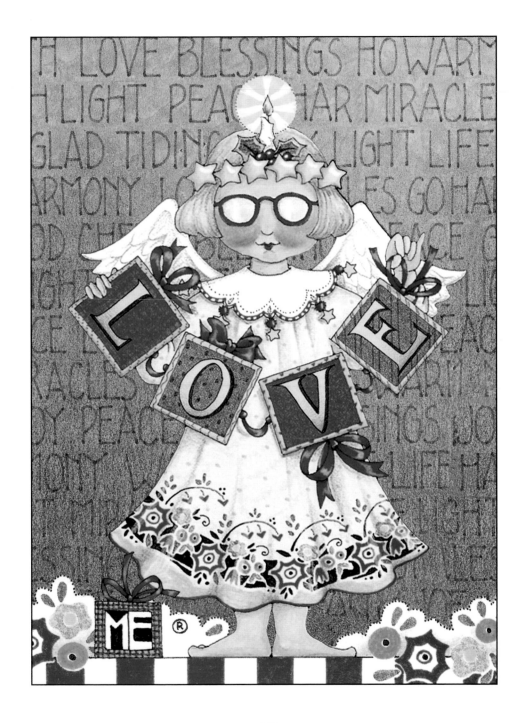

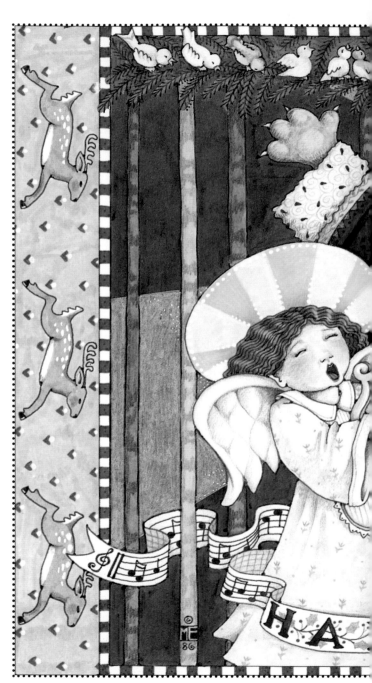

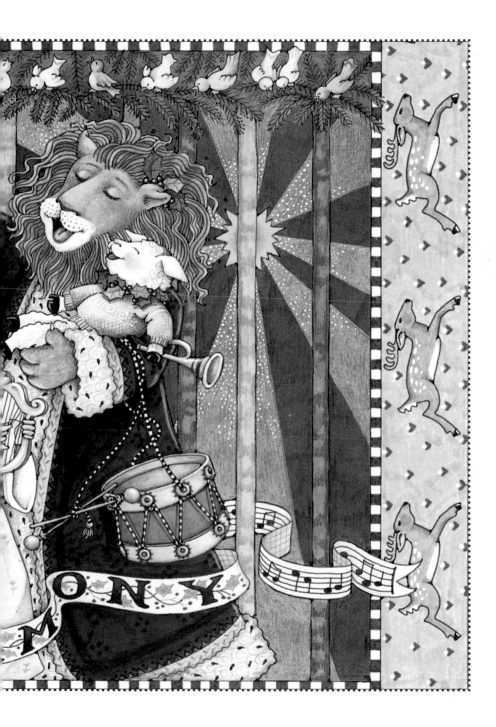

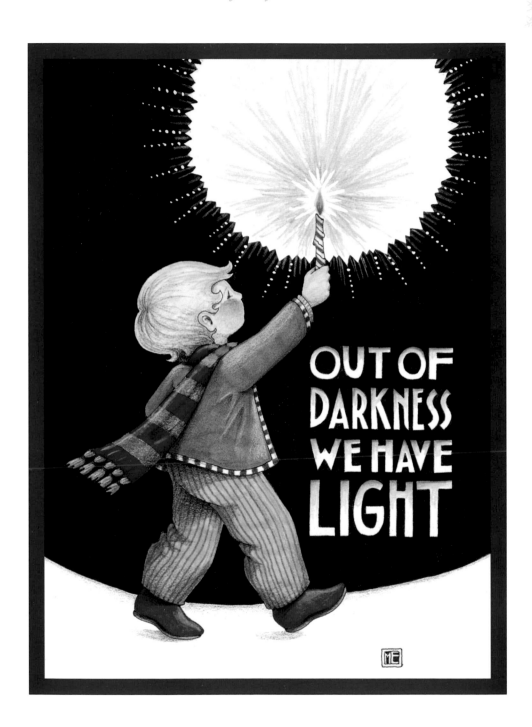

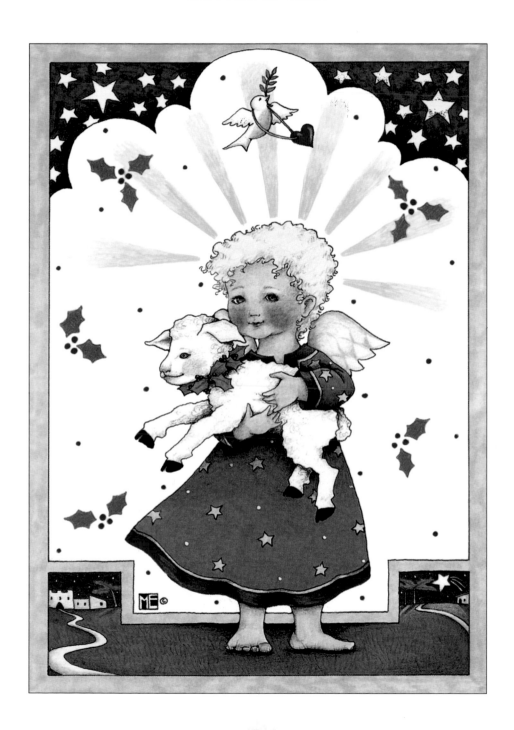

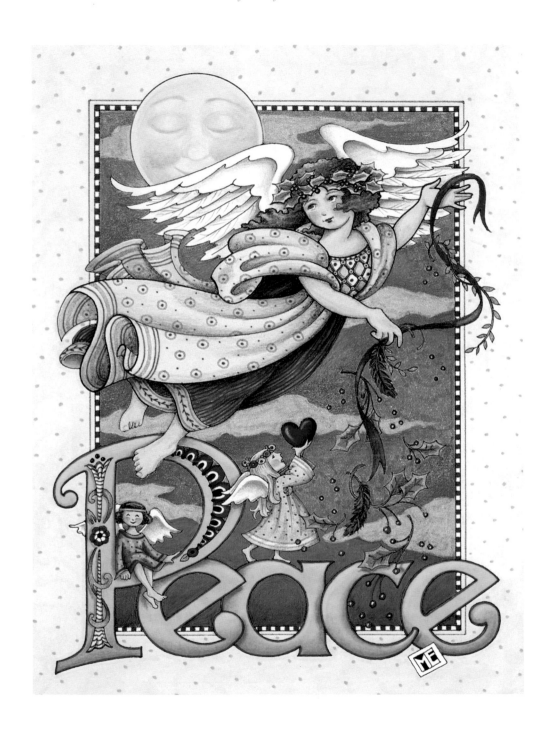

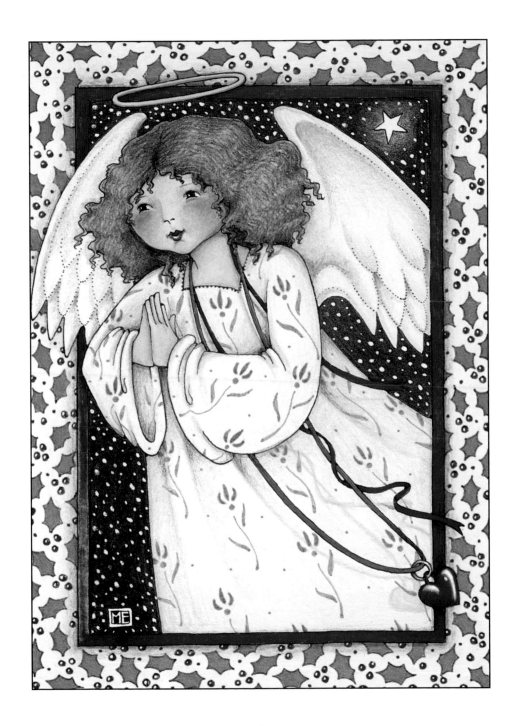

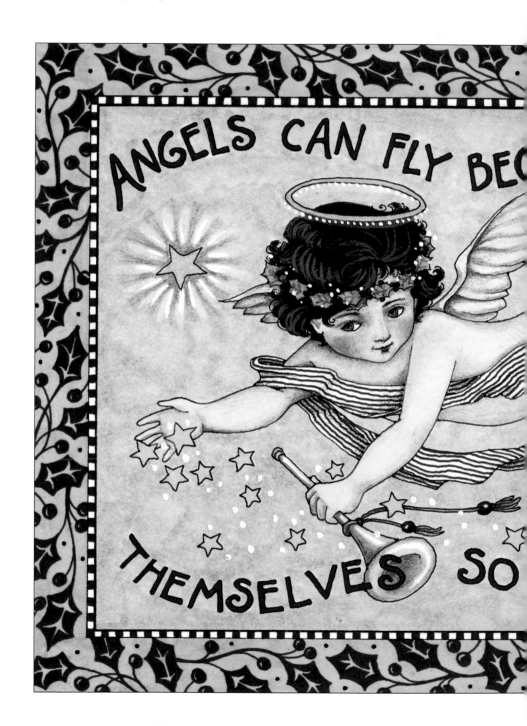

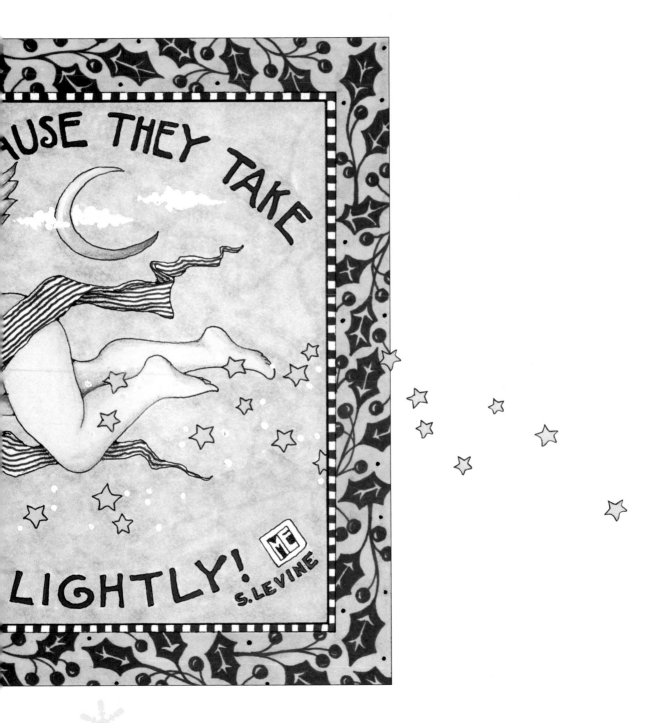

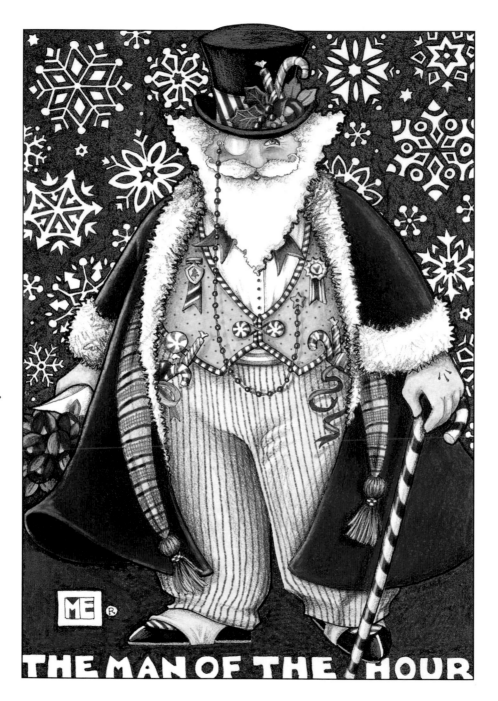

THE MAN OF THE HOUR

the man of the hour

has any single person ever been the source of more joy, giggles, dreams, whispered wishes, stories and instantaneously impeccable behavior by otherwise unruly children than the one and only Mr. Kris Kringle?

Does anyone else embody the spirit of giving, the fun of the season, and the thrill of believing in magic more than Jolly Old St. Nick?

There's no doubt about it . . . Santa is the Man of the Hour, appearing for one night only on a rooftop near you. But make no mistake—his is no part-time job. Why, what with scheduling, planning, toy-building, sleigh maintenance, and list-making, he's swamped all year long. And reindeer? Well, they don't feed themselves, you know.

Christmas and Santa go hand-in-hand. But remember, he holds us in his heart all year long. Now, wouldn't this old world be a nicer place if we did the same for him?

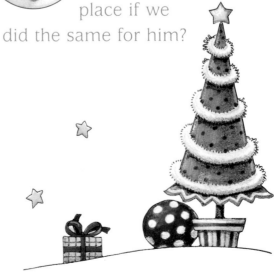

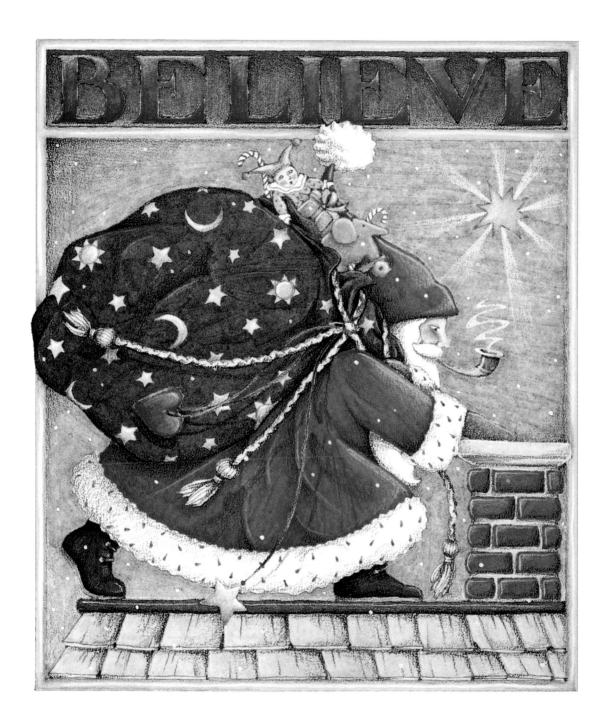

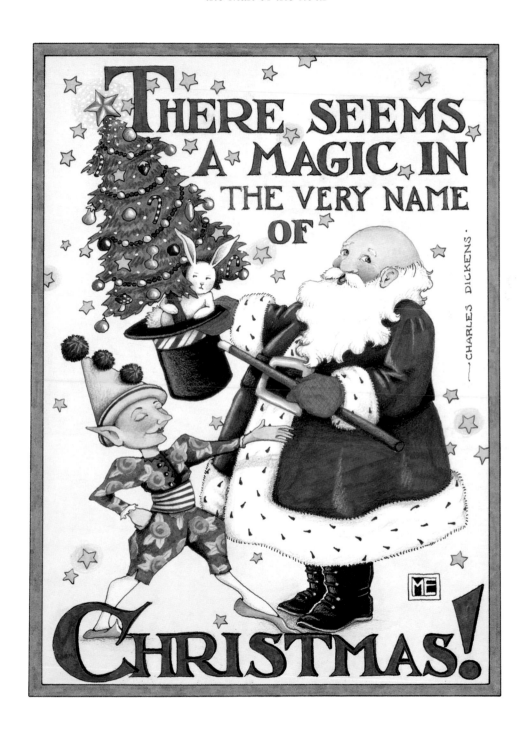

THERE SEEMS A MAGIC IN THE VERY NAME OF

—CHARLES DICKENS·

CHRISTMAS!

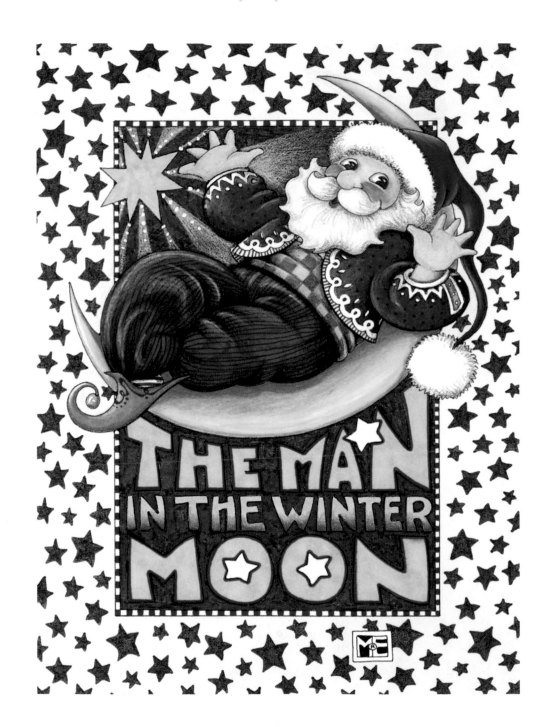

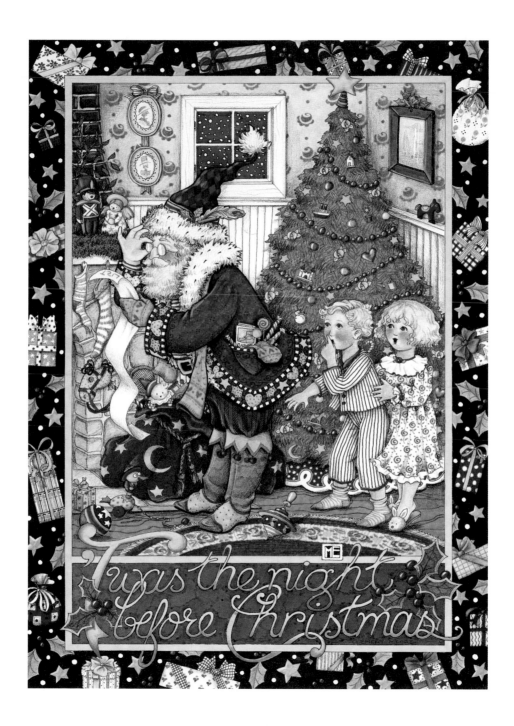

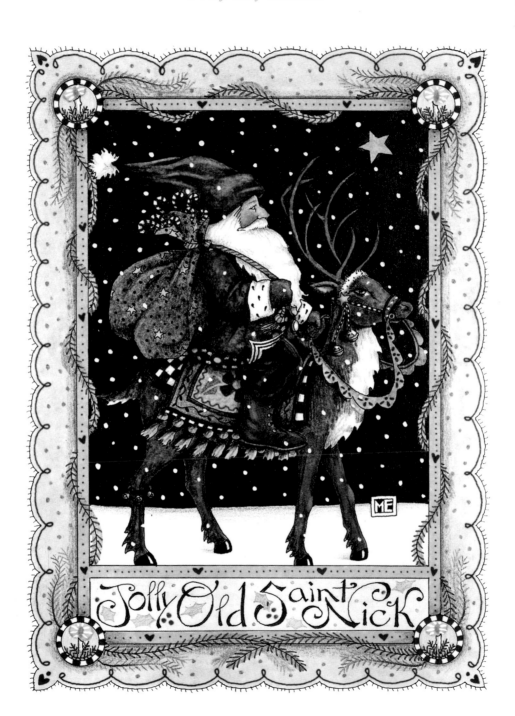

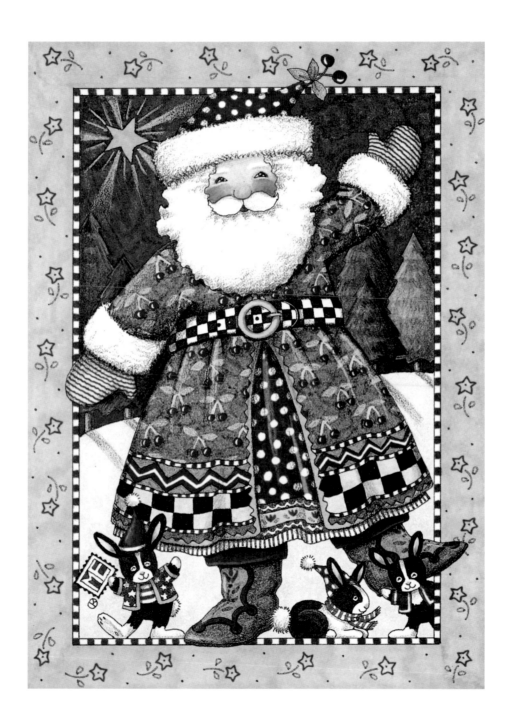

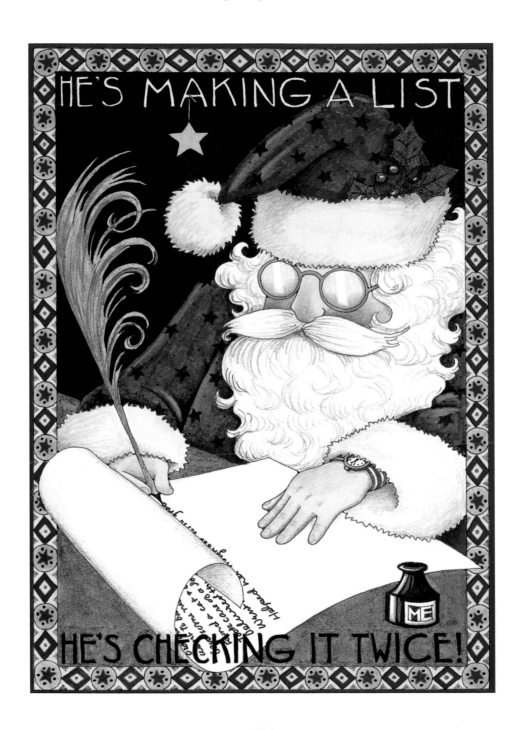

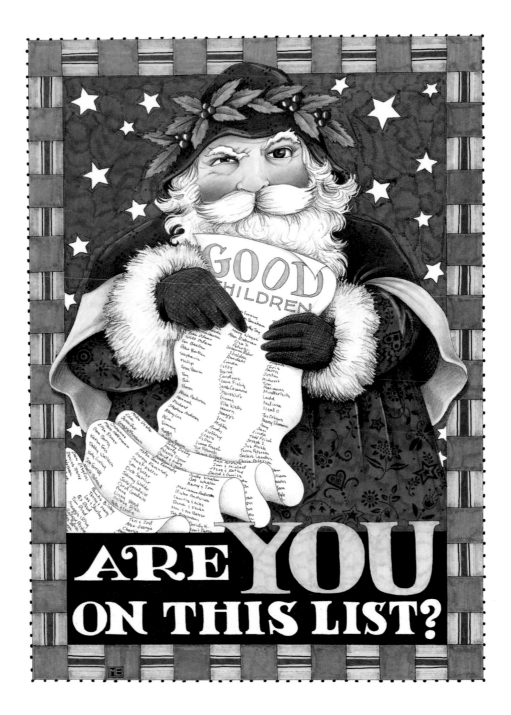

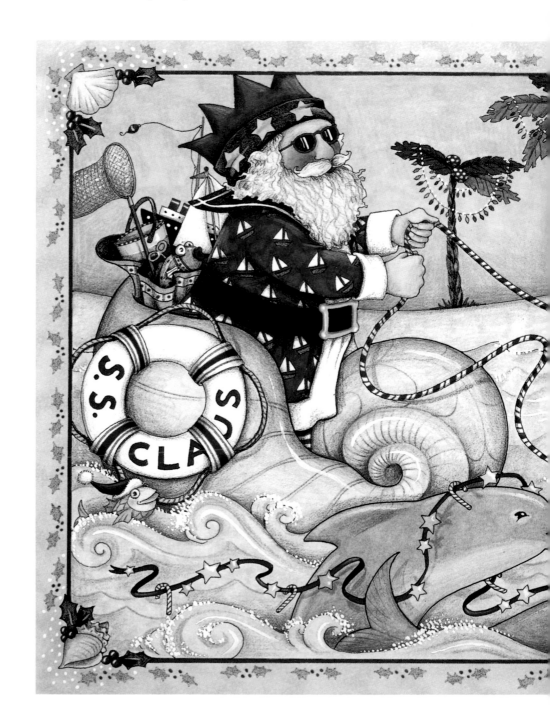

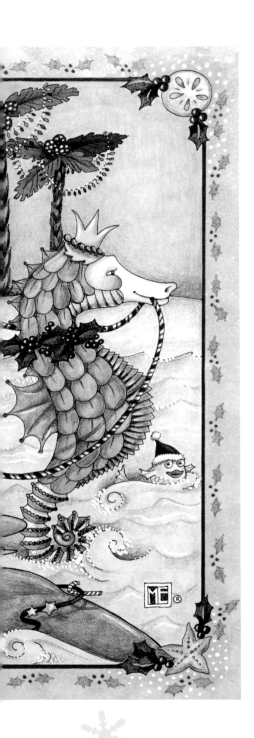

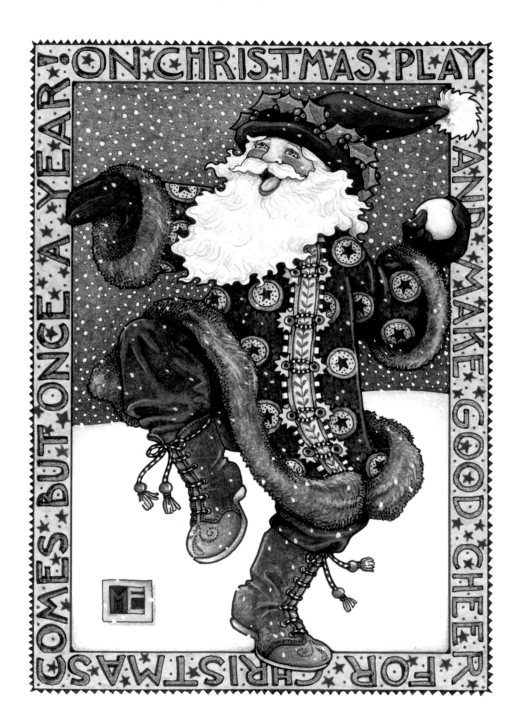

ON CHRISTMAS PLAY AND MAKE GOOD CHEER FOR CHRISTMAS COMES BUT ONCE A YEAR!

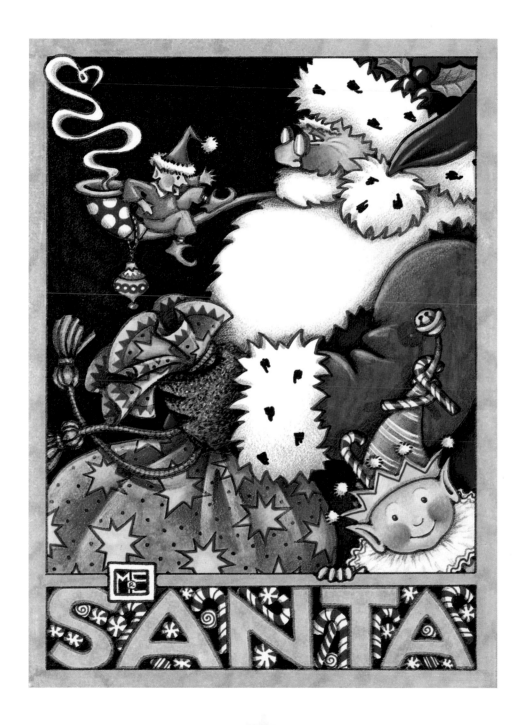

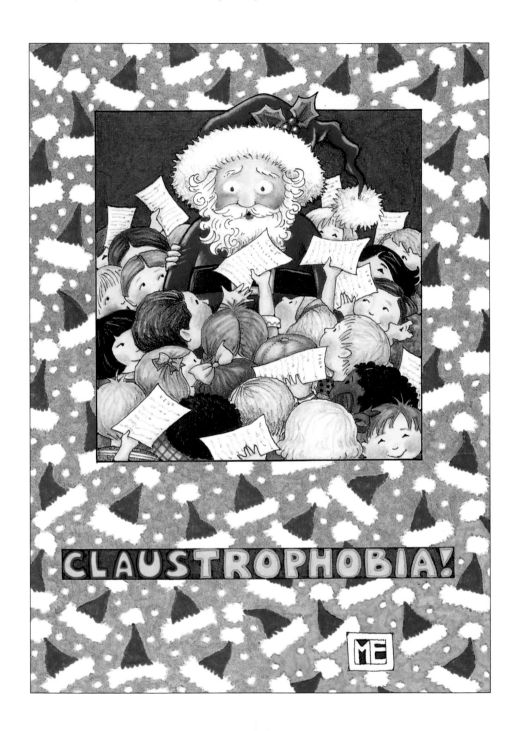

CLAUSTROPHOBIA!

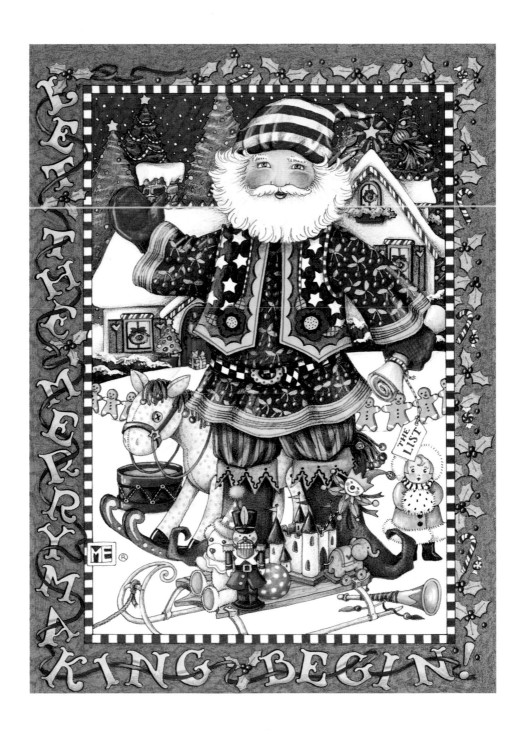

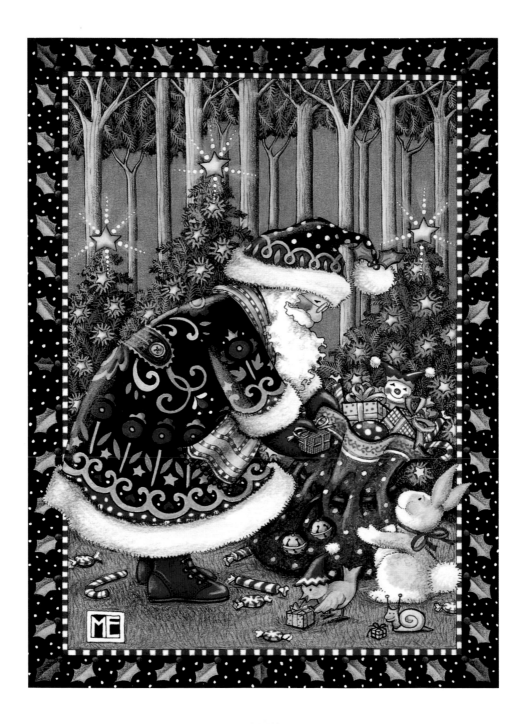

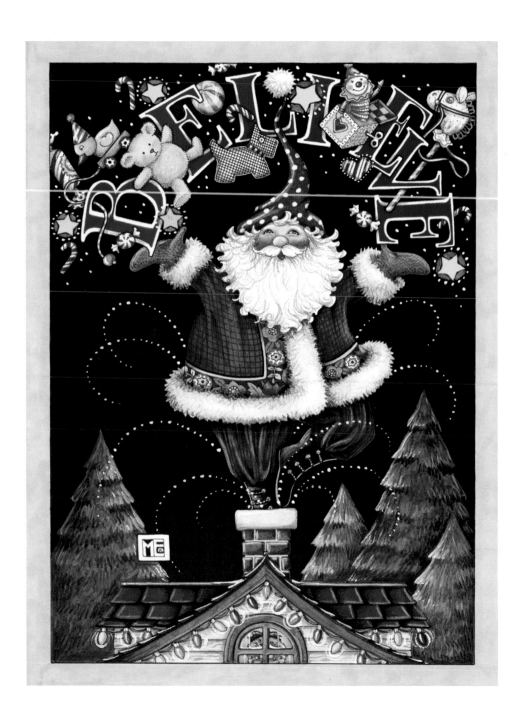

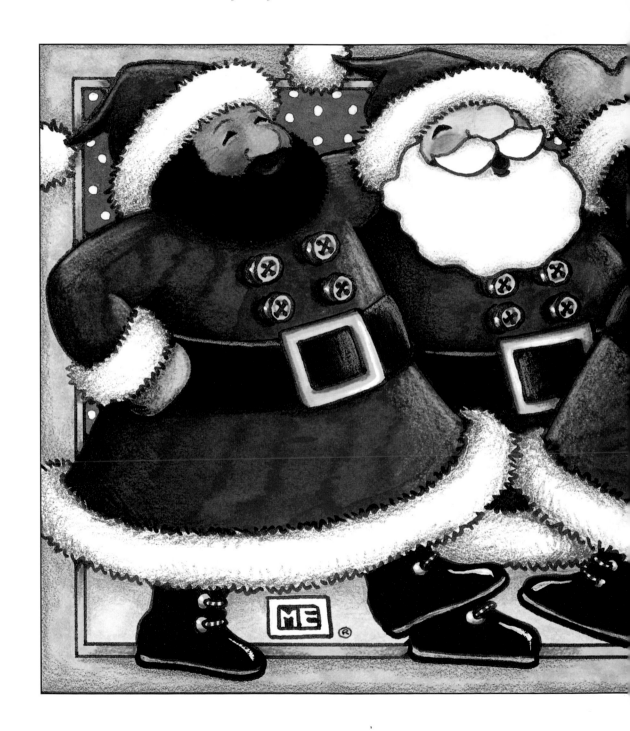

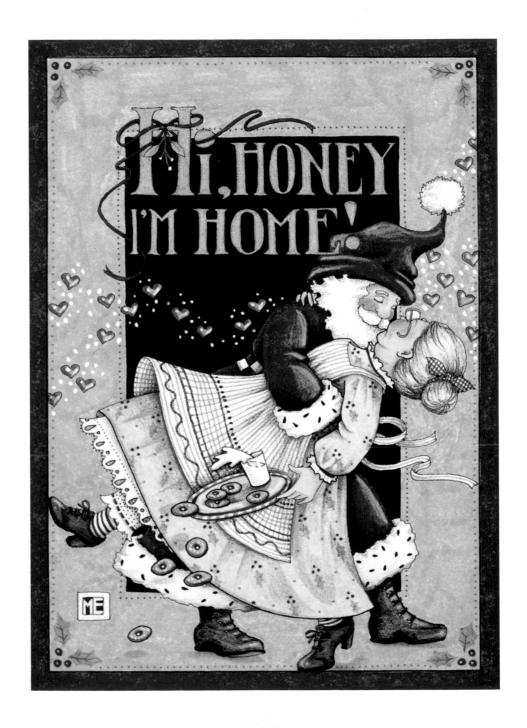

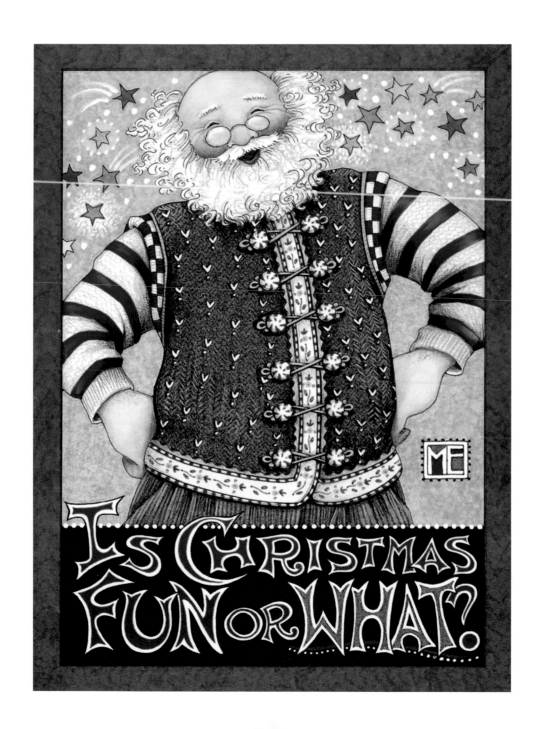

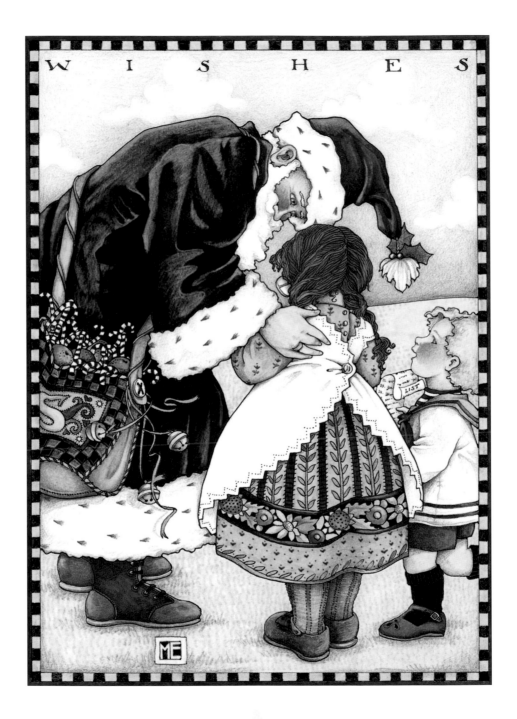

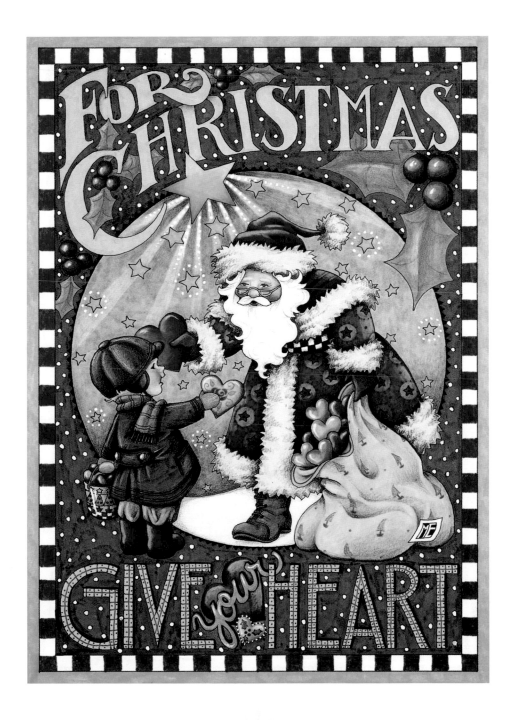

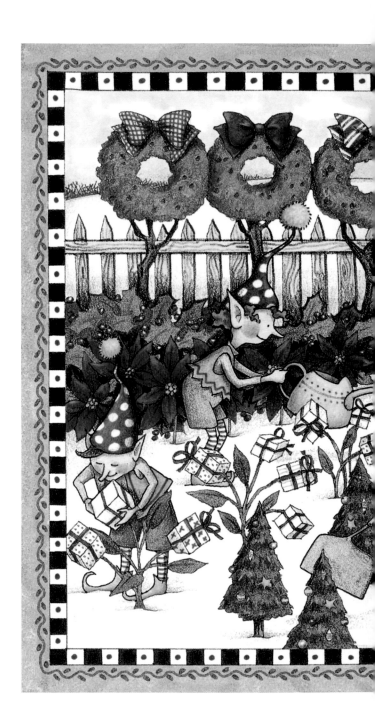

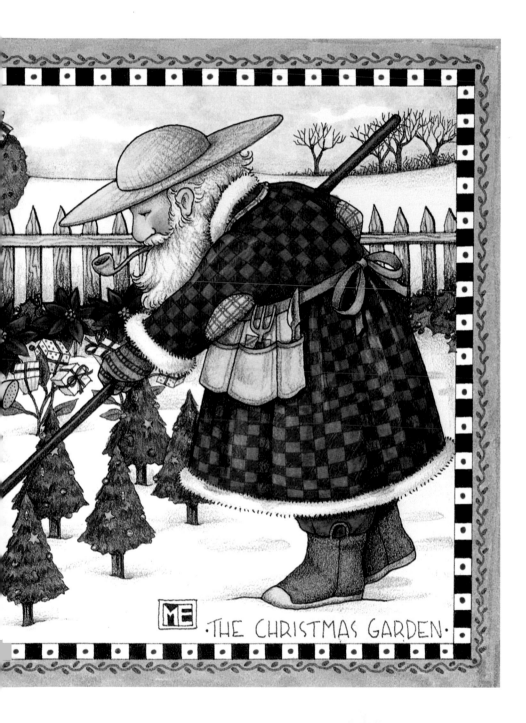

·THE CHRISTMAS GARDEN·

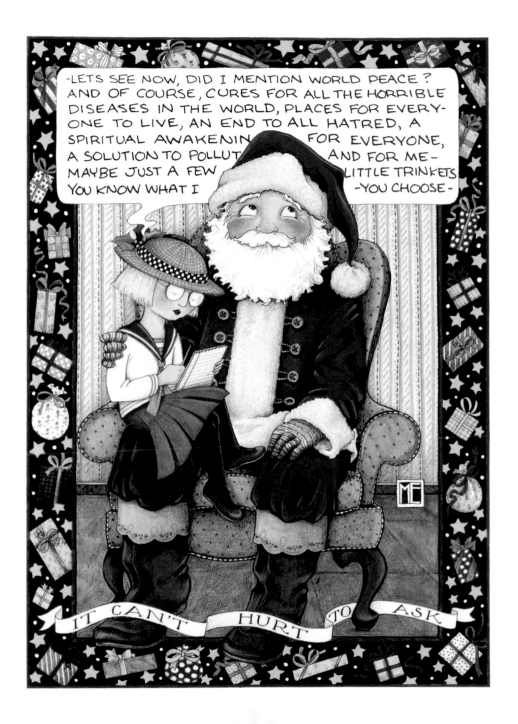

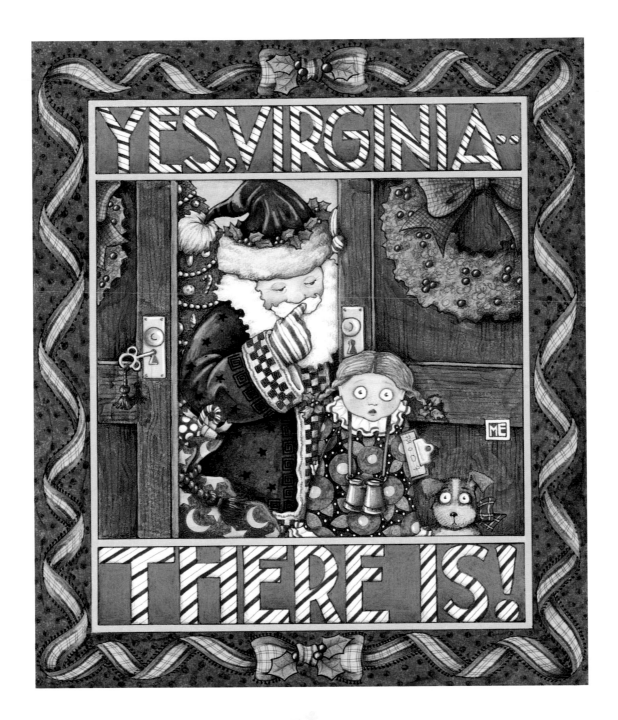

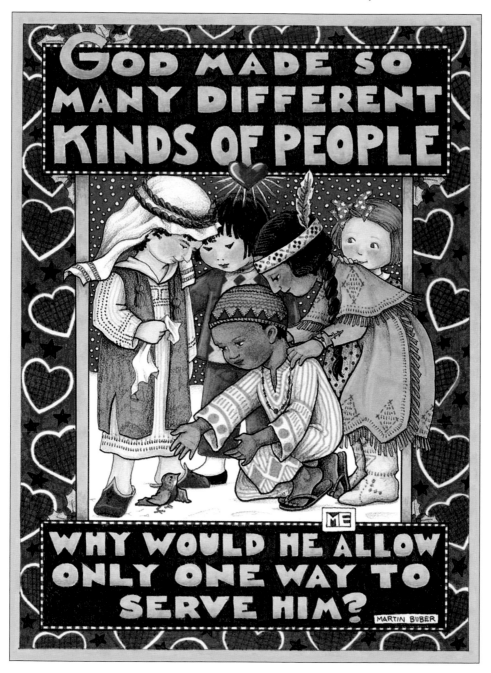

its mighty founder was a child himself

It is often said that Christmas makes children of all of us. What a joyous reality that would be! If we could find in ourselves the purity and unconditional love bestowed in all children at birth...then we could remember what is truly important.

But on Christmas, we are reminded, "For on this day, a child is born unto you." A single child, humbly born in a stable . . . born to lead us, to unite us, to remind all of us that we too are God's children. We too carry inside of us an unlimited capacity to love. We too can be whole once again.

The beginning is not only near—it's here. Here in a cradle crudely drawn from straw—an answer to so many peoples' search for guidance and direction. Day of light. Day of birth. Here is God come to Earth.

THE TIME DRAWS NEAR THE BIRTH OF CHRIST;
THE MOON IS HID; THE NIGHT IS STILL;
THE CHRISTMAS BELLS FROM HILL TO HILL
ANSWER EACH OTHER IN THE MIST.

·—ALFRED, LORD TENNYSON·

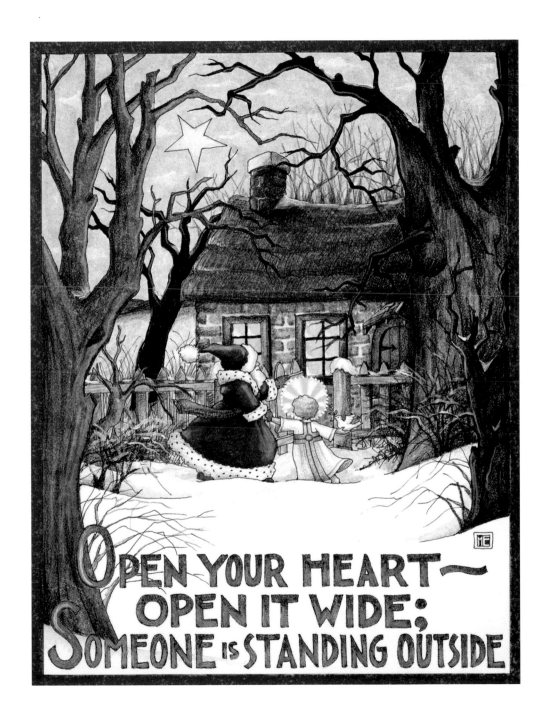

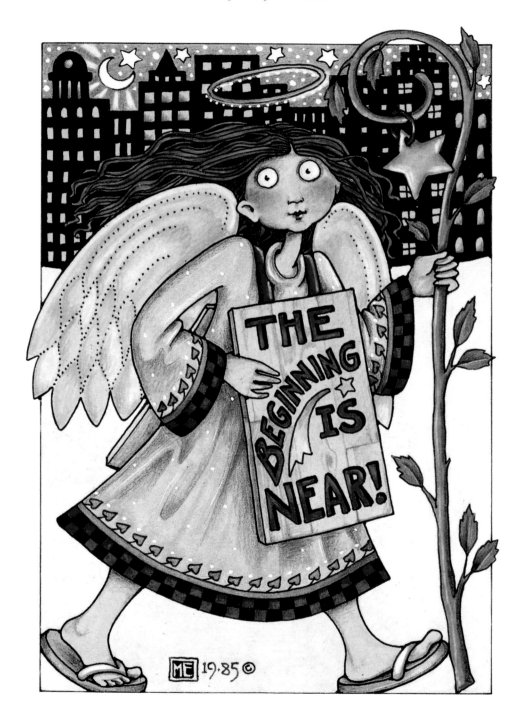

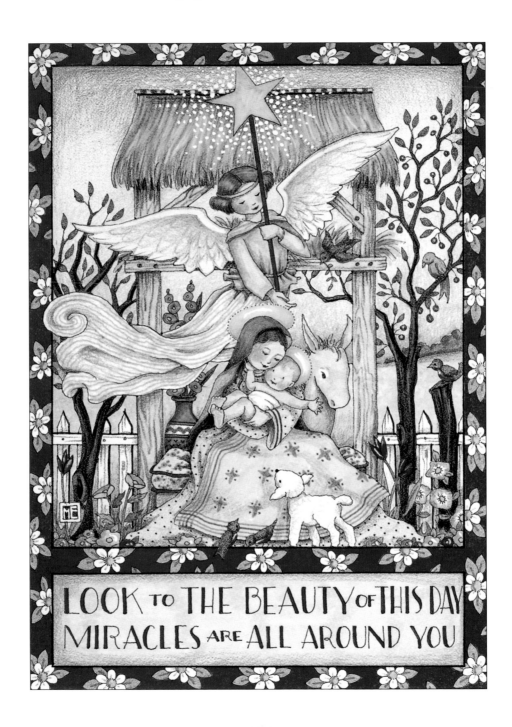

LOOK TO THE BEAUTY OF THIS DAY
MIRACLES ARE ALL AROUND YOU

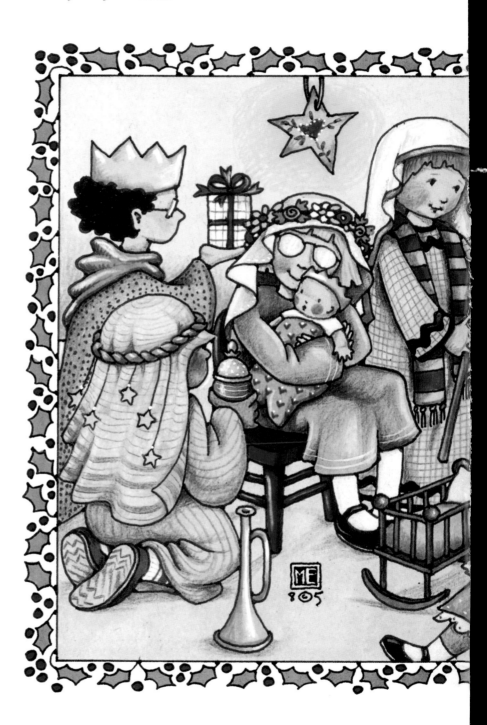

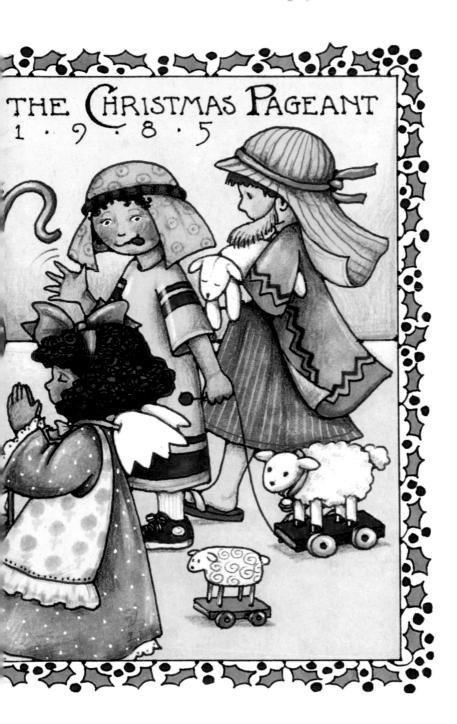

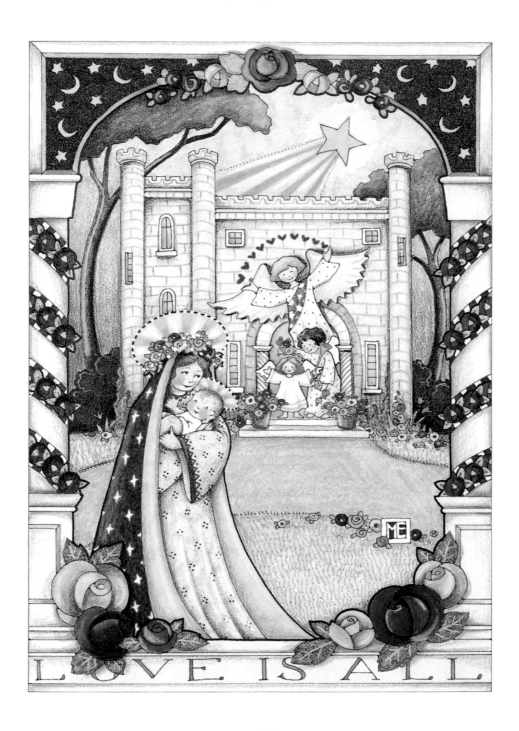

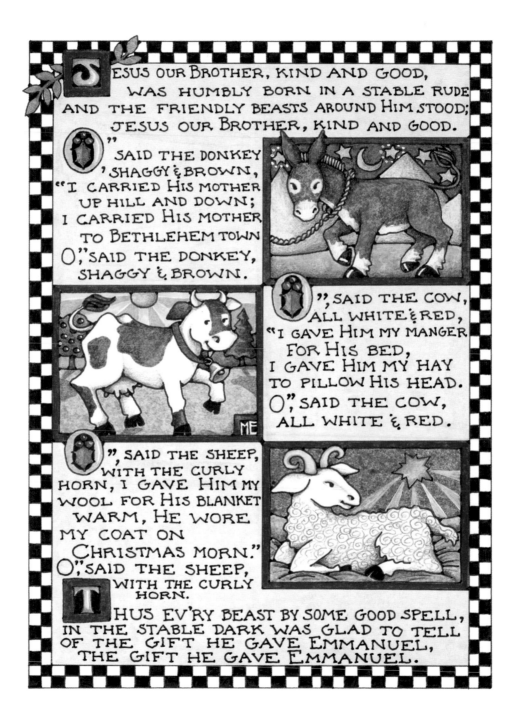

JESUS OUR BROTHER, KIND AND GOOD,
WAS HUMBLY BORN IN A STABLE RUDE
AND THE FRIENDLY BEASTS AROUND HIM STOOD;
JESUS OUR BROTHER, KIND AND GOOD.

"I," SAID THE DONKEY, SHAGGY & BROWN,
"I CARRIED HIS MOTHER UP HILL AND DOWN;
I CARRIED HIS MOTHER TO BETHLEHEM TOWN
O," SAID THE DONKEY, SHAGGY & BROWN.

"I," SAID THE COW, ALL WHITE & RED,
"I GAVE HIM MY MANGER FOR HIS BED,
I GAVE HIM MY HAY TO PILLOW HIS HEAD.
O," SAID THE COW, ALL WHITE & RED.

"I," SAID THE SHEEP, WITH THE CURLY HORN, I GAVE HIM MY WOOL FOR HIS BLANKET WARM, HE WORE MY COAT ON CHRISTMAS MORN."
O," SAID THE SHEEP, WITH THE CURLY HORN.

THUS EV'RY BEAST BY SOME GOOD SPELL,
IN THE STABLE DARK WAS GLAD TO TELL
OF THE GIFT HE GAVE EMMANUEL,
THE GIFT HE GAVE EMMANUEL.

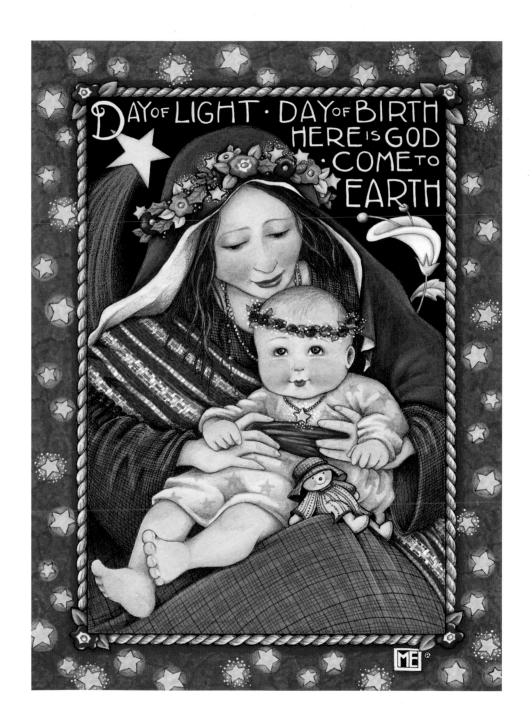